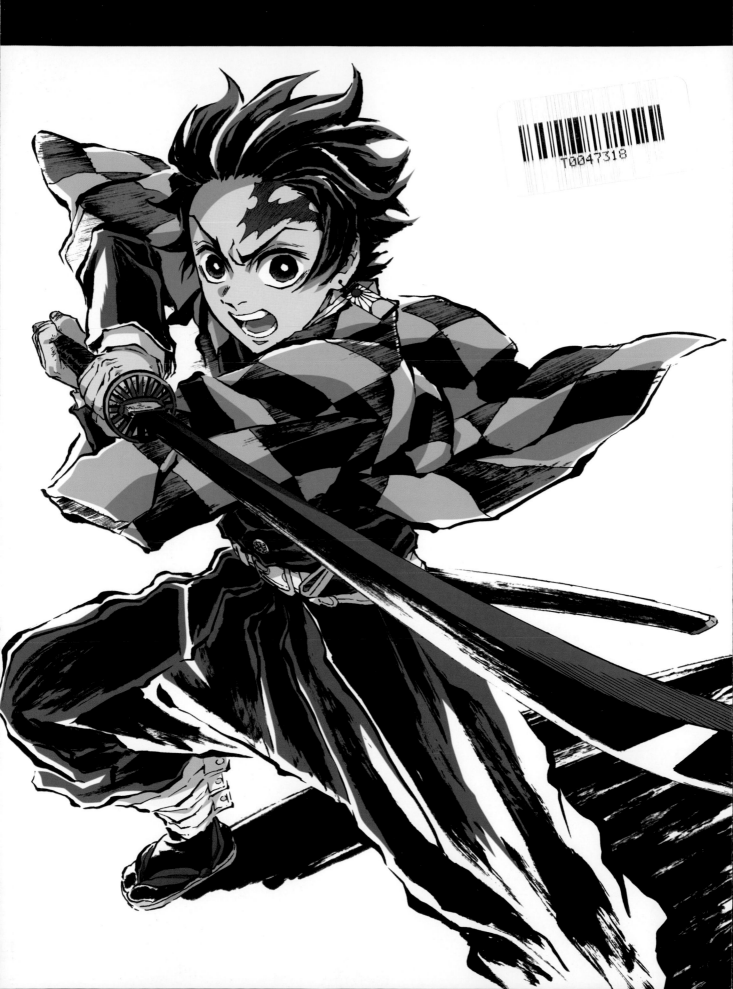

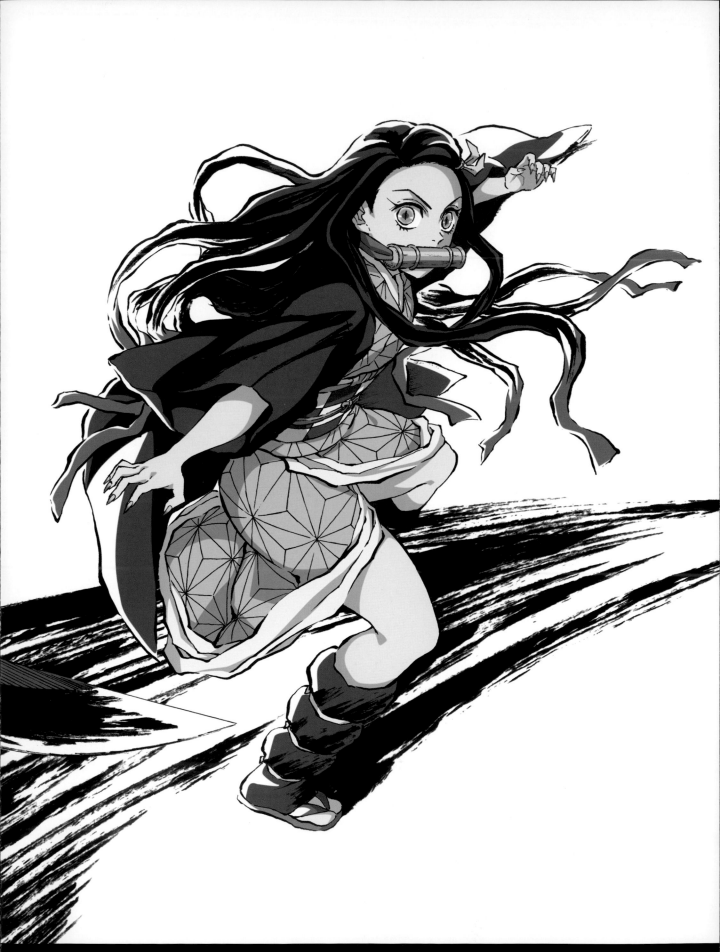

THE ART OF DEMON SLAYER
KIMETSU NO YAIBA

THE ANIME
VOLUME ONE

CONTENTS

This book is a collection of illustrations produced by ufotable for the *Demon Slayer: Kimetsu no Yaiba* anime between June 2018 and March 2020.

**PART 1
KEY VISUALS**

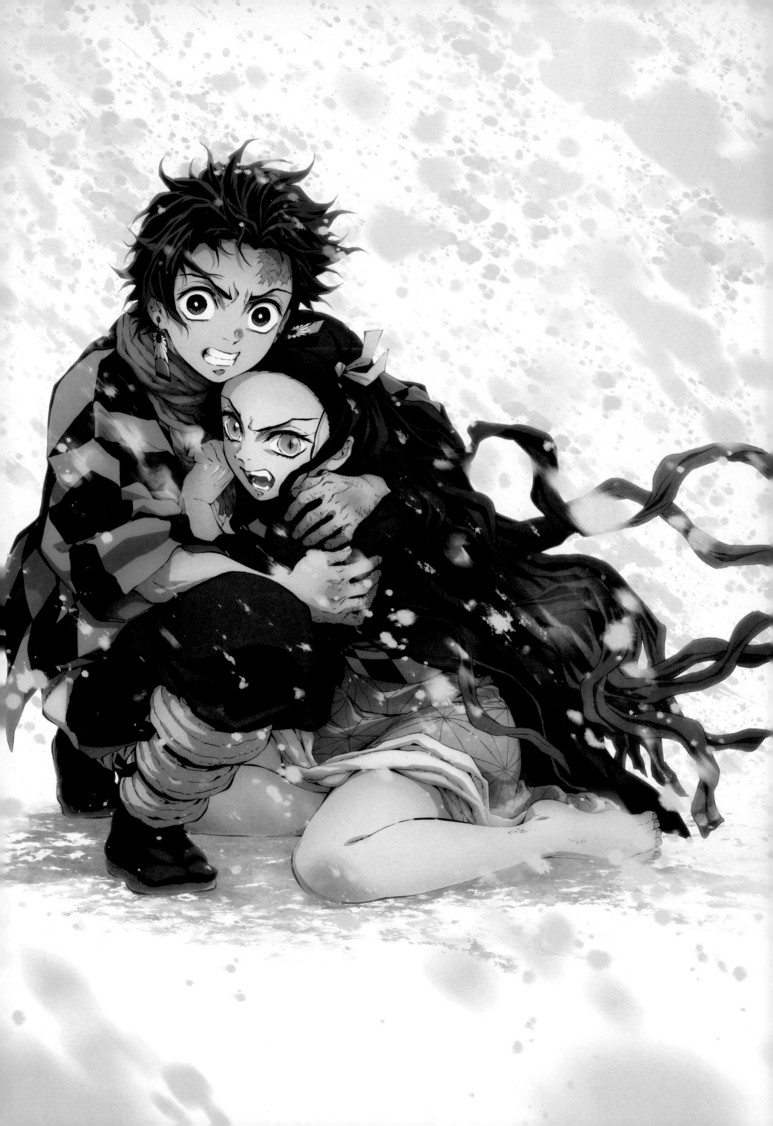

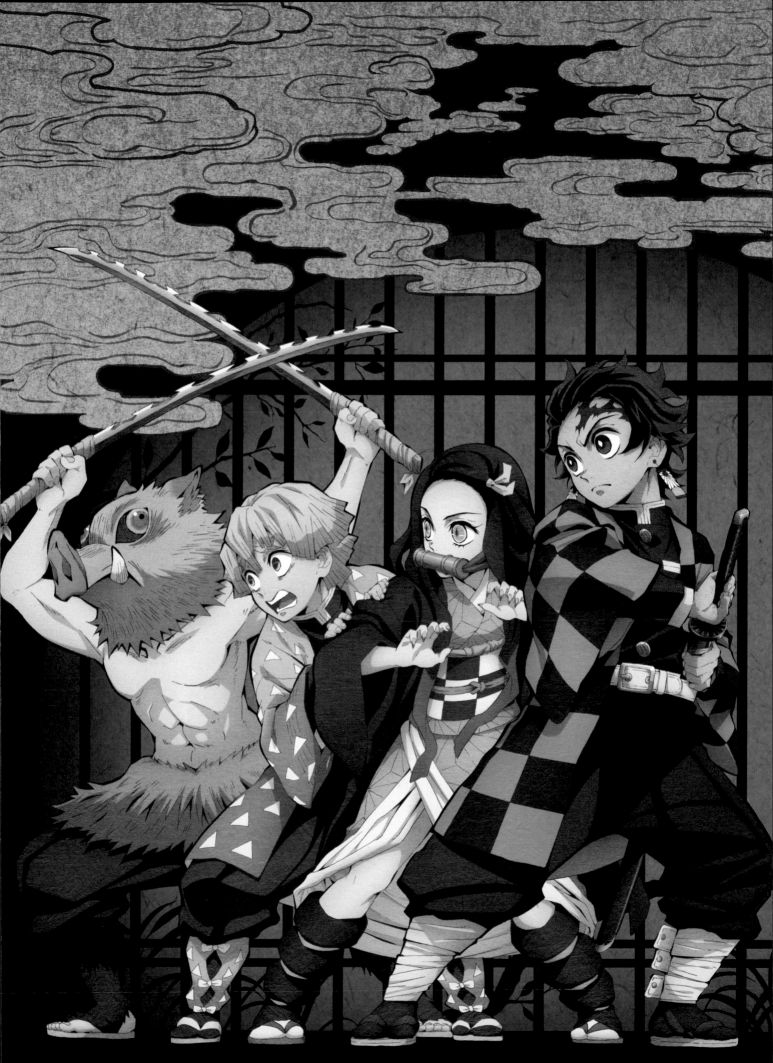

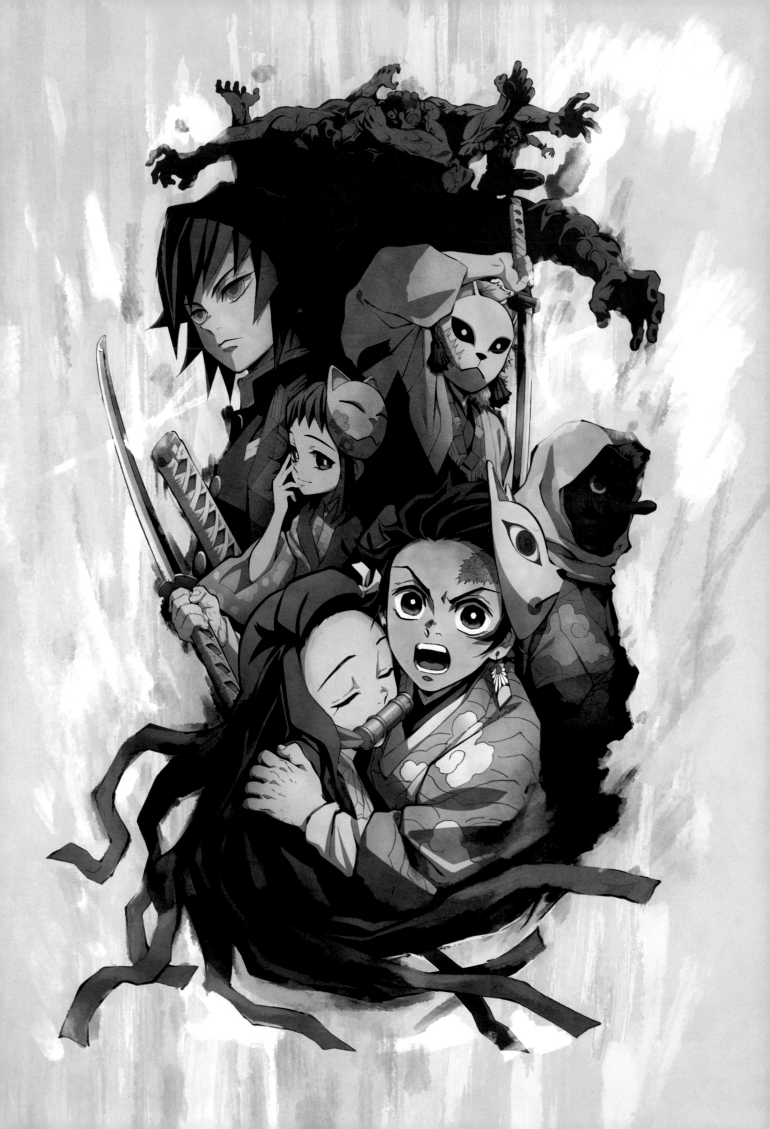

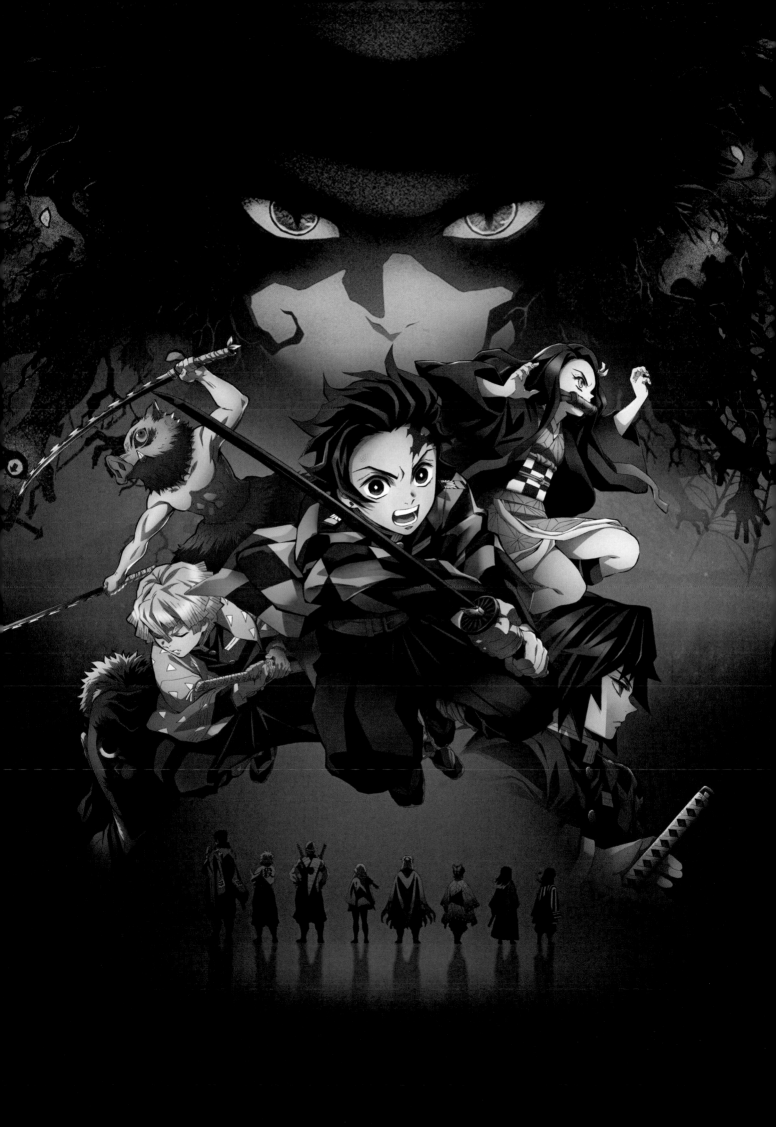

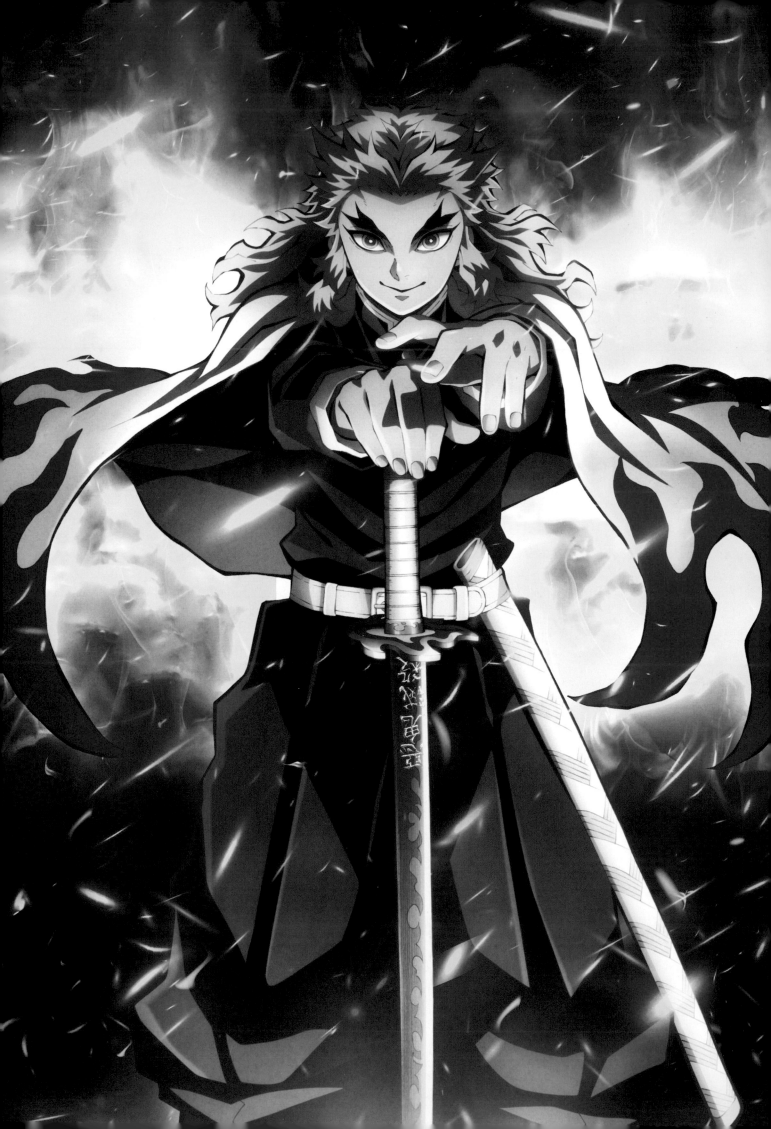

PART 2
PROMOTIONAL ILLUSTRATIONS

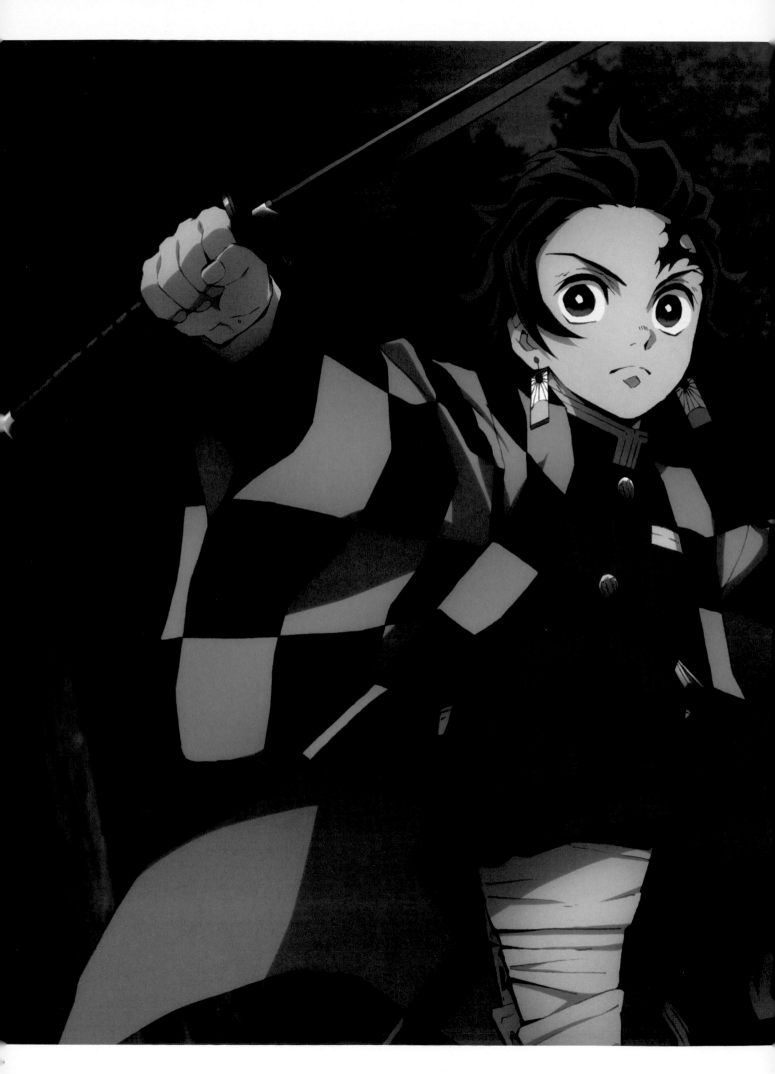

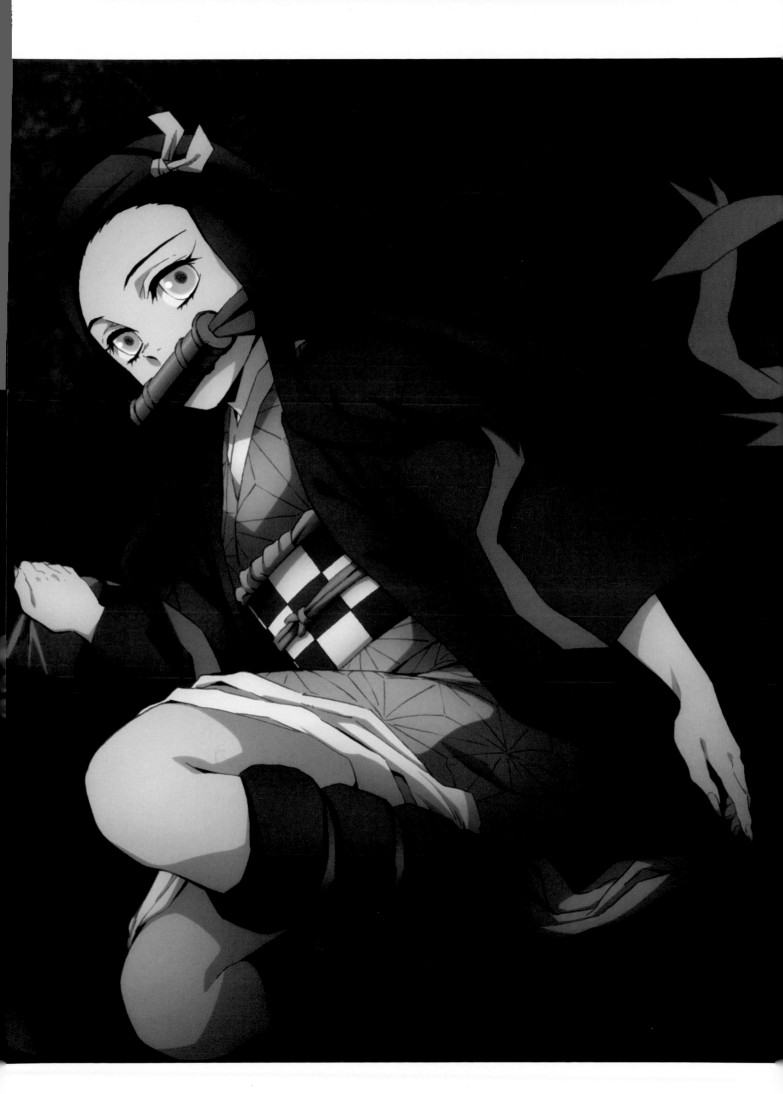

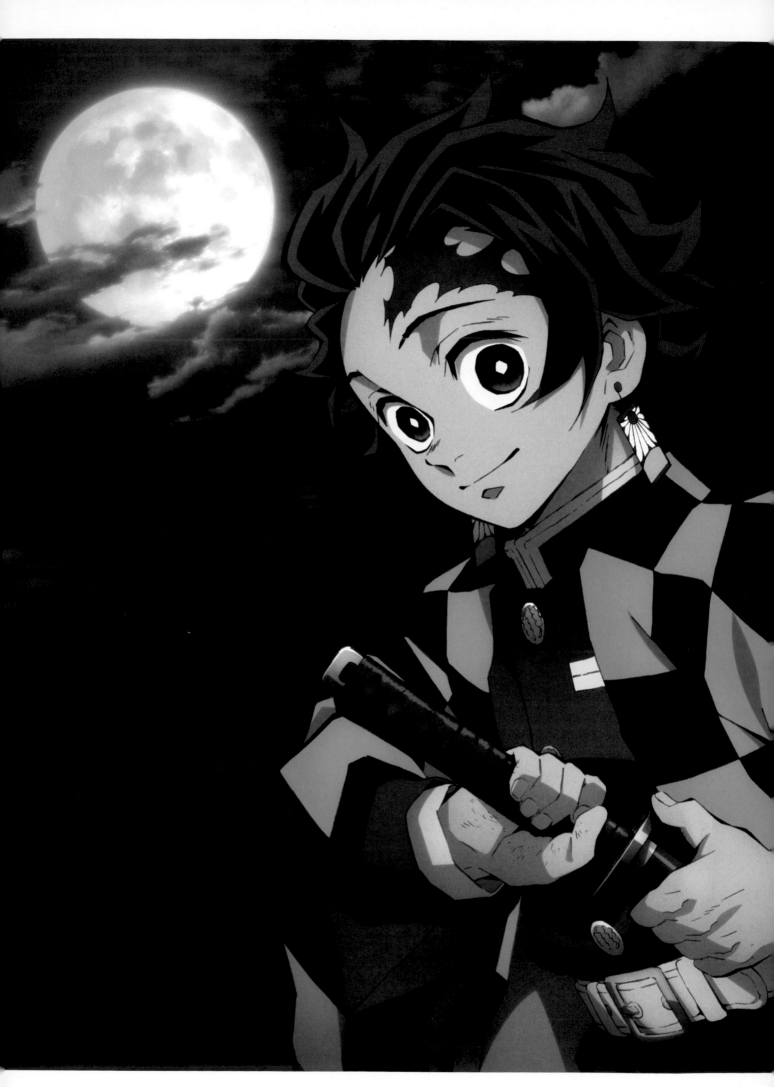

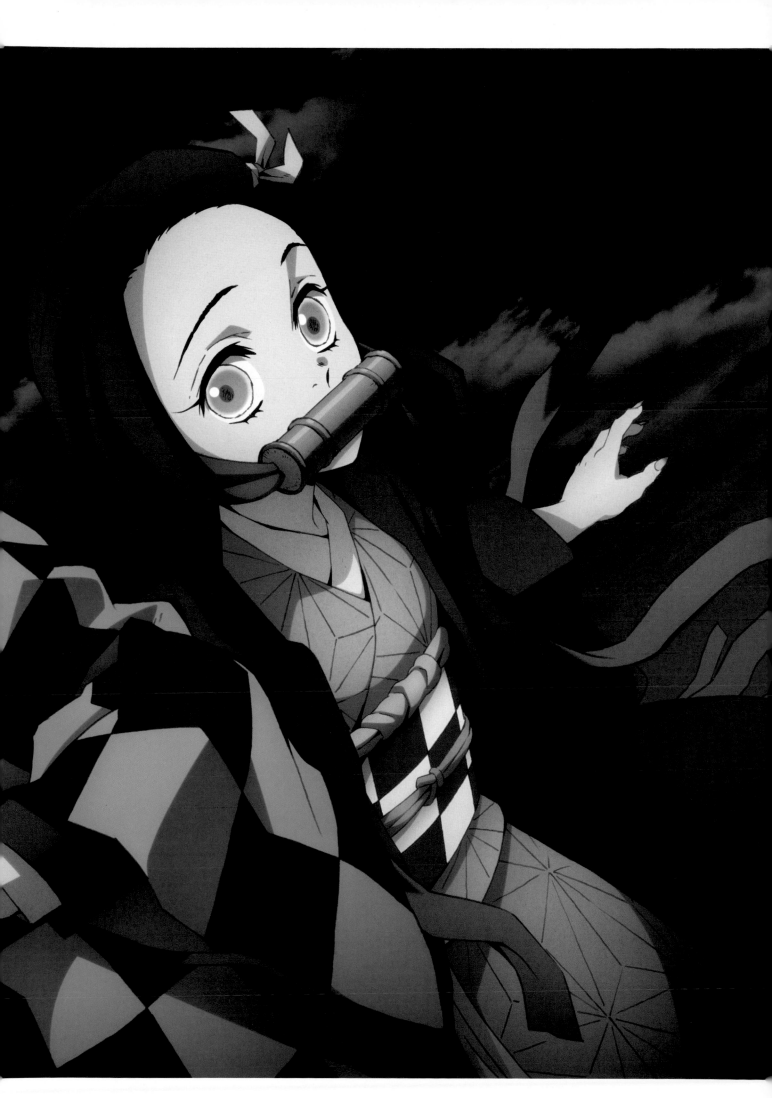

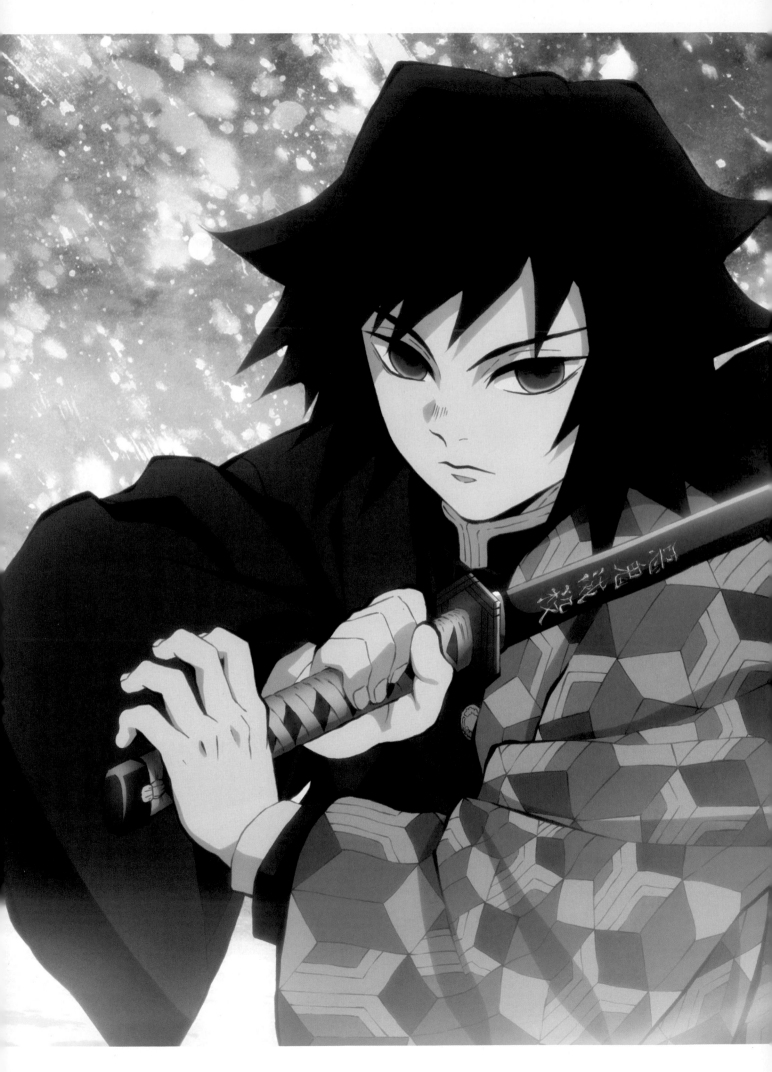

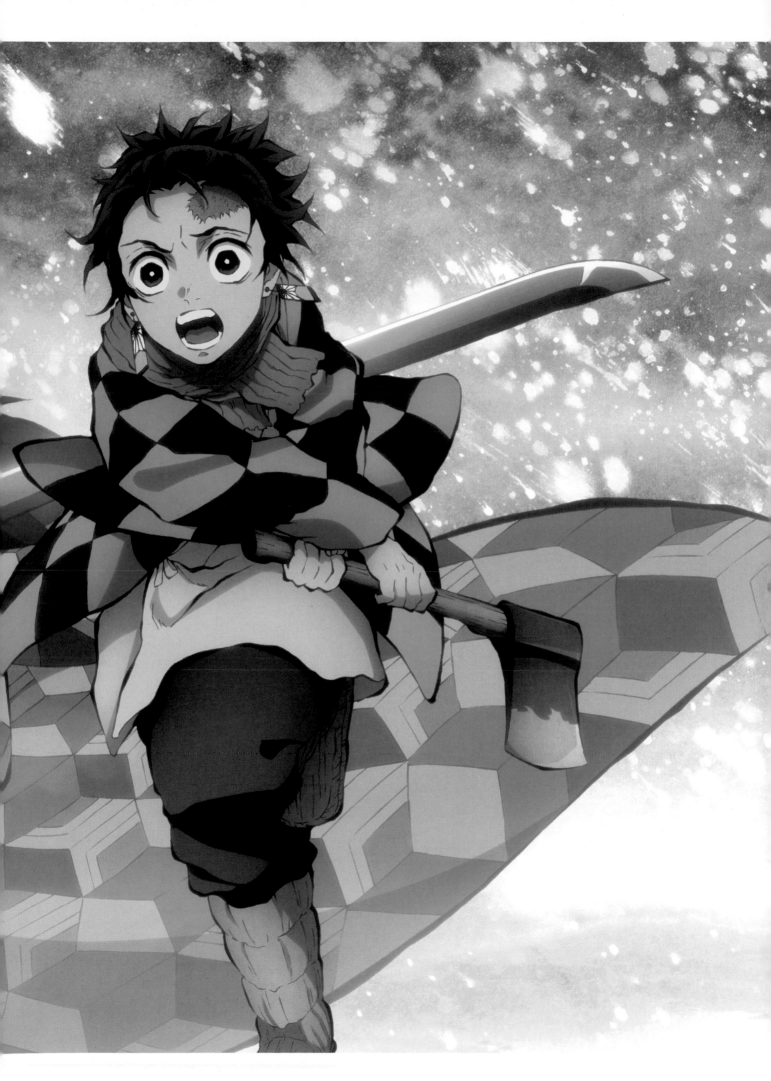

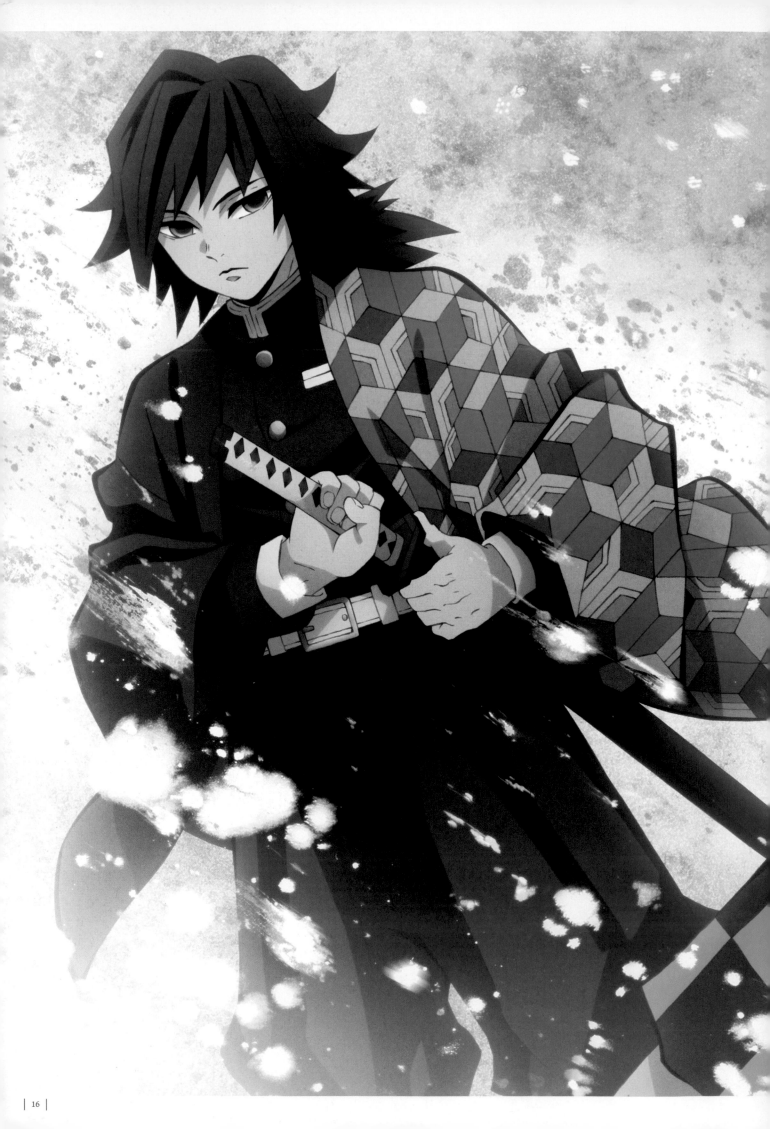

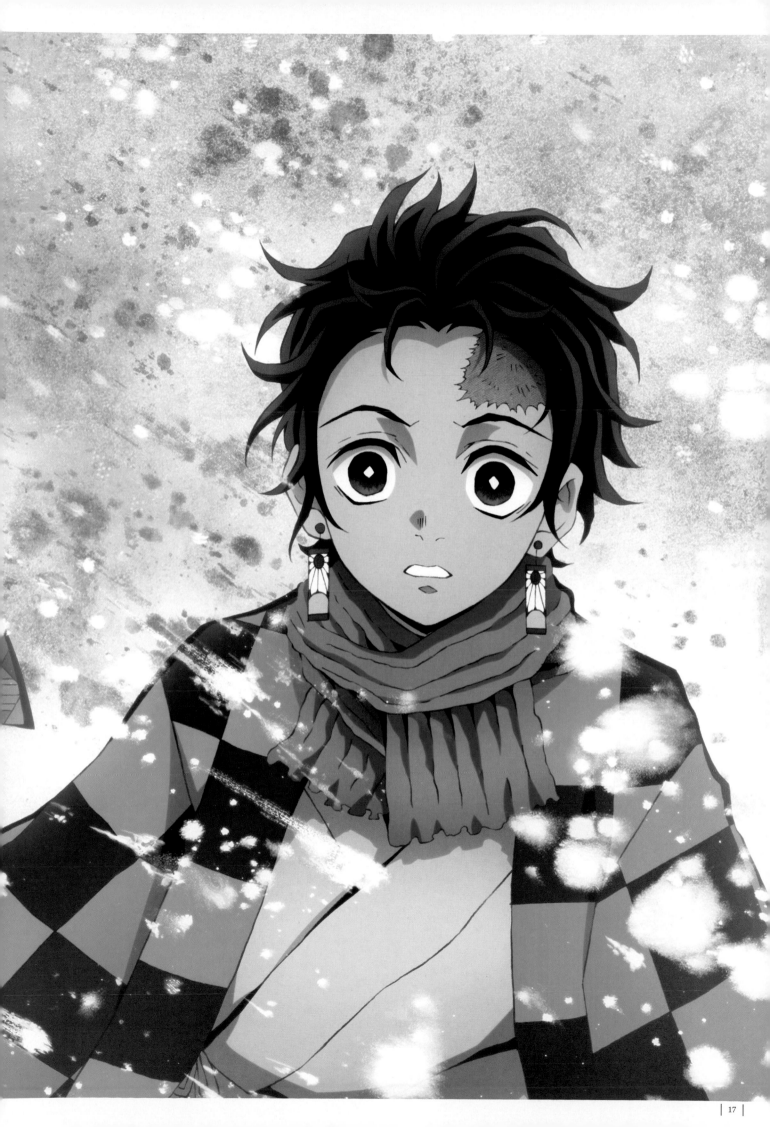

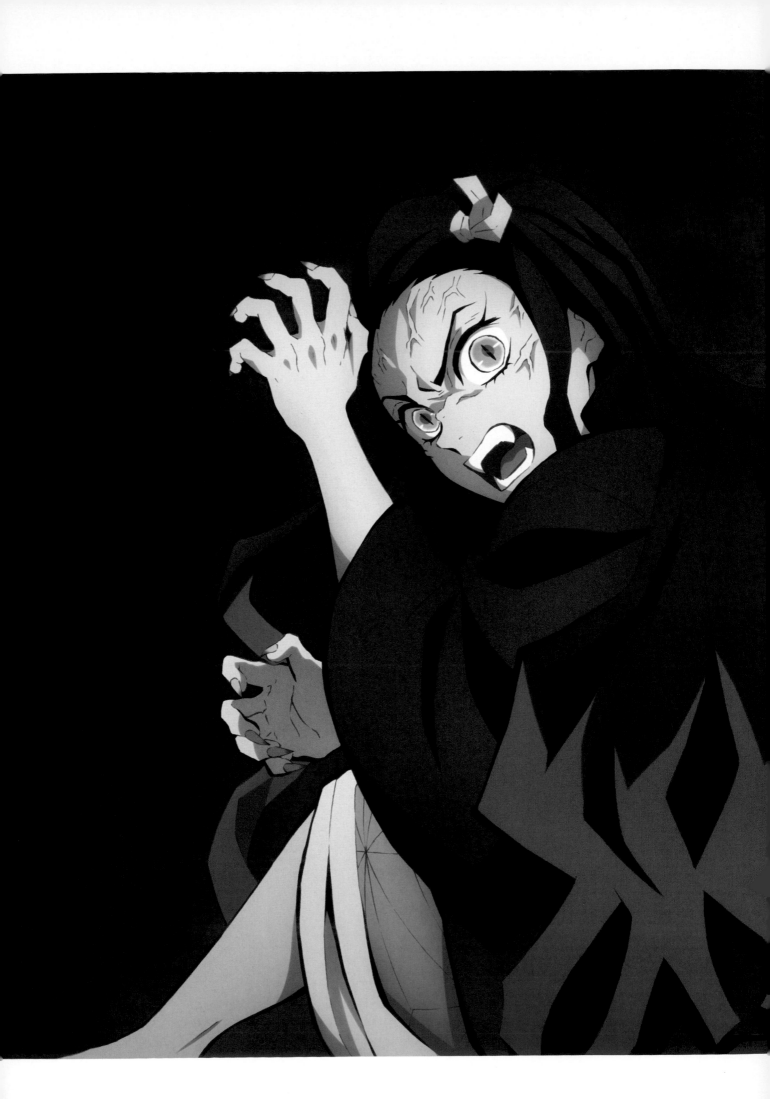

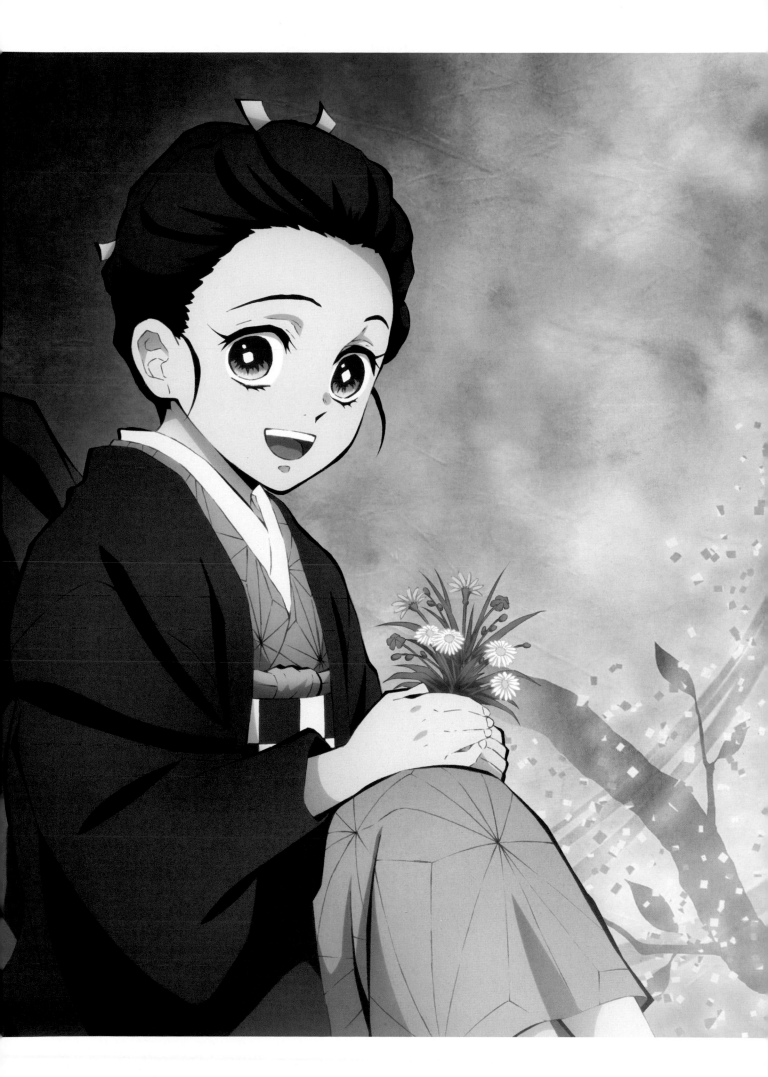

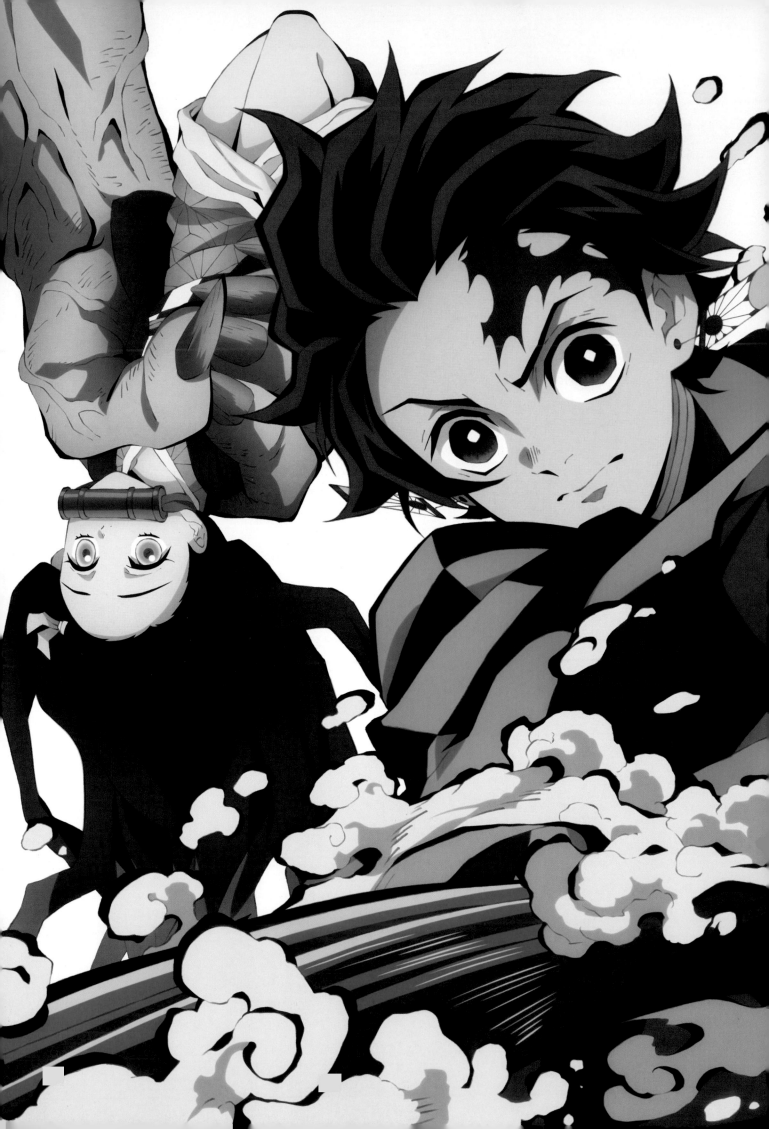

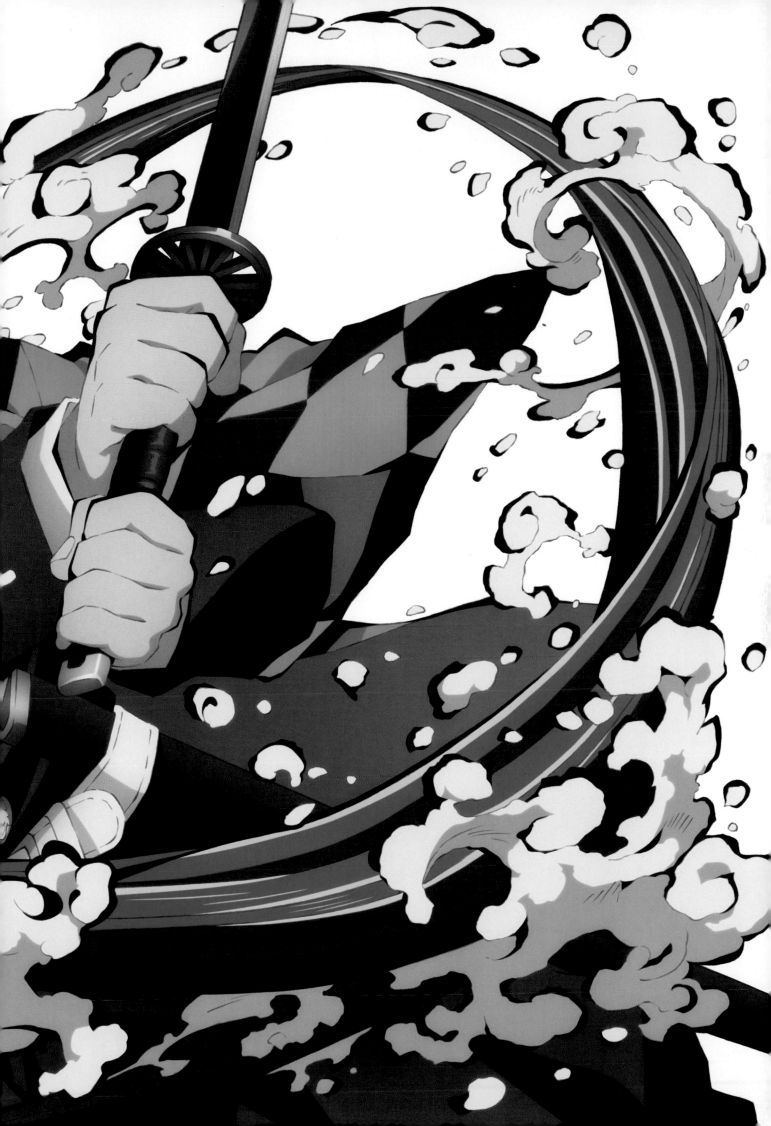

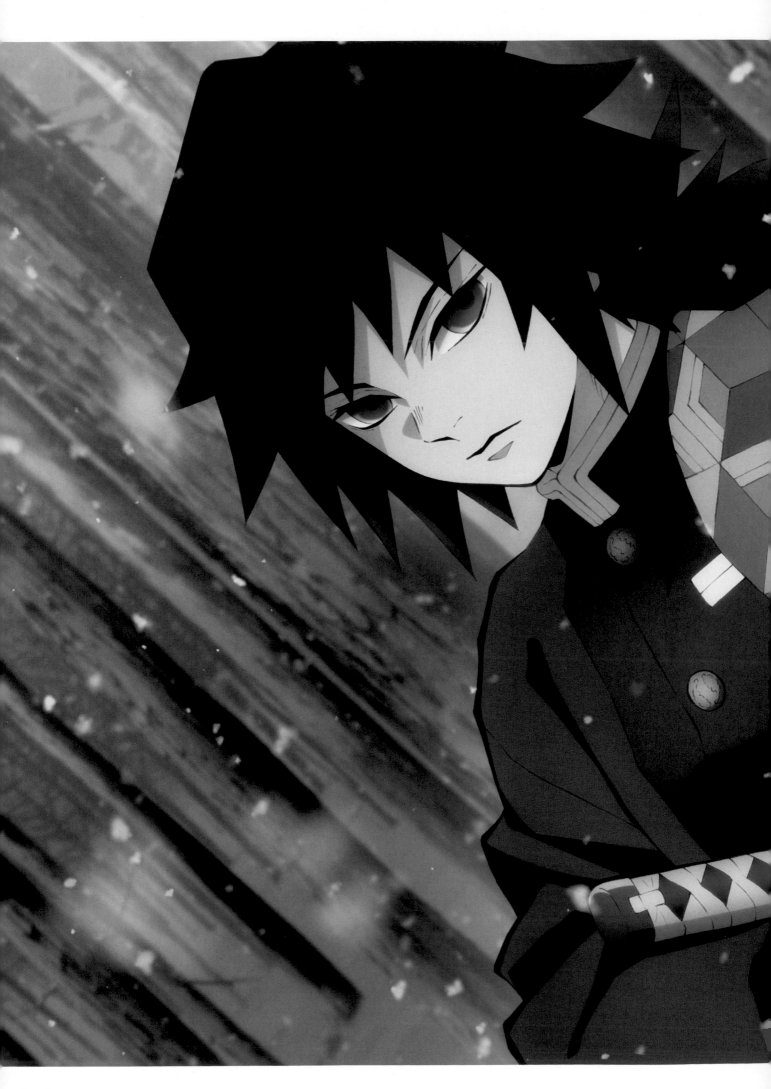

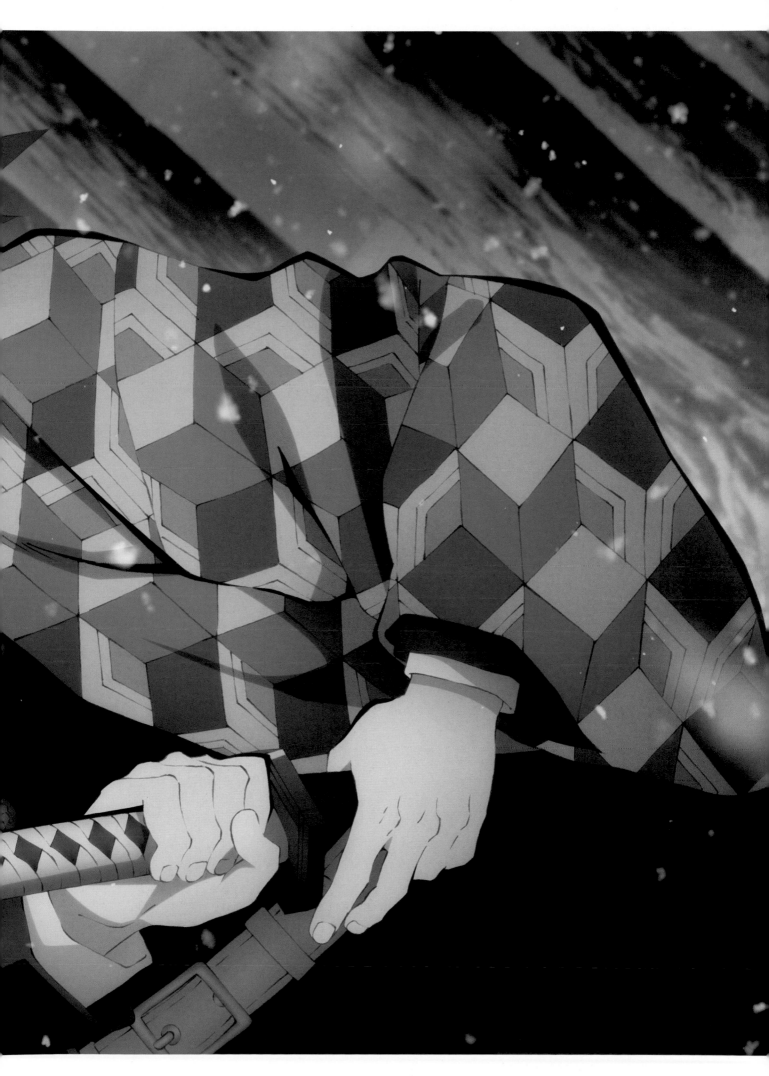

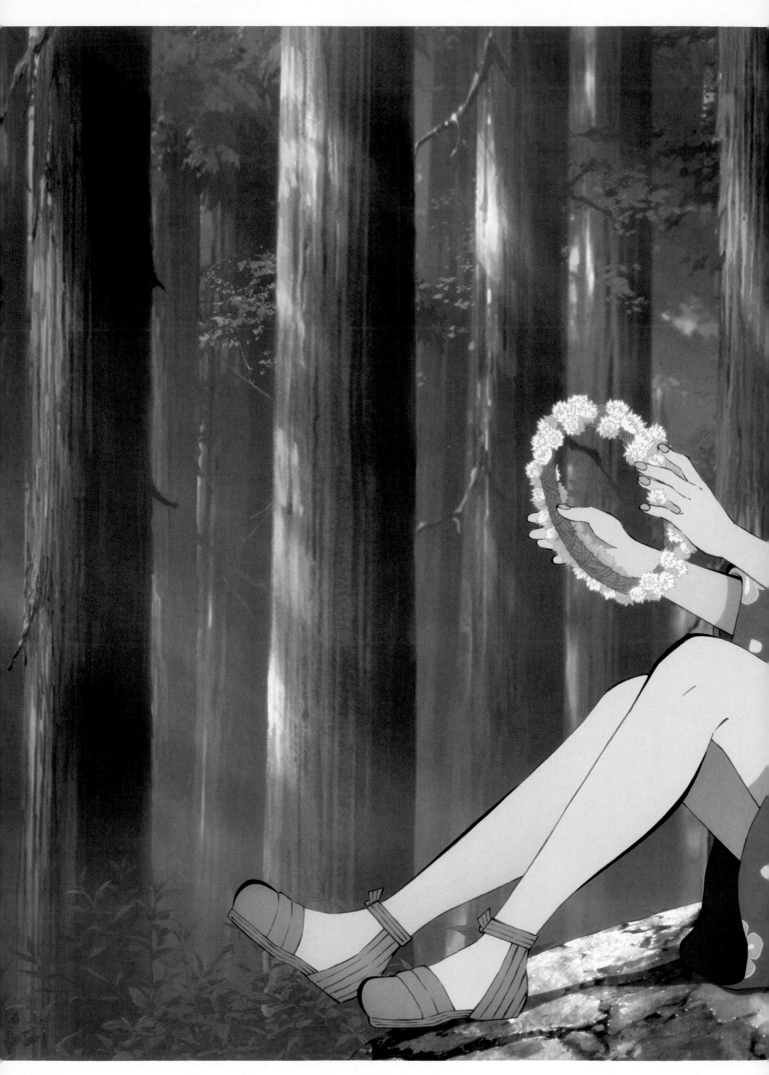

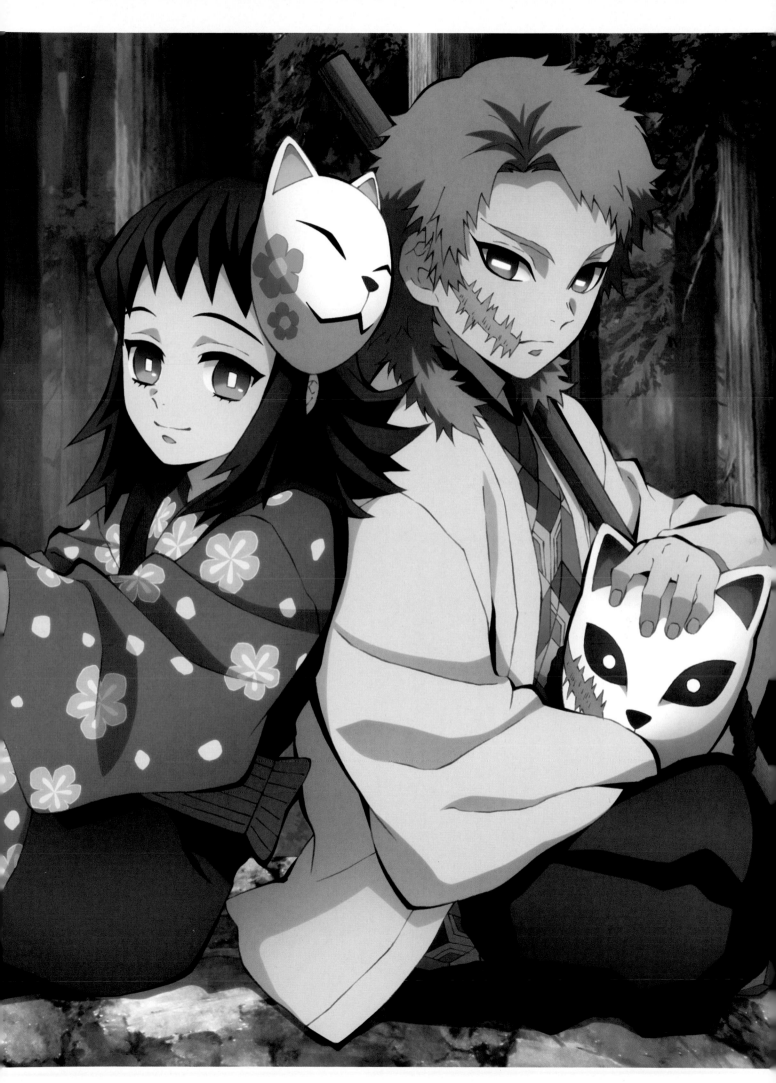

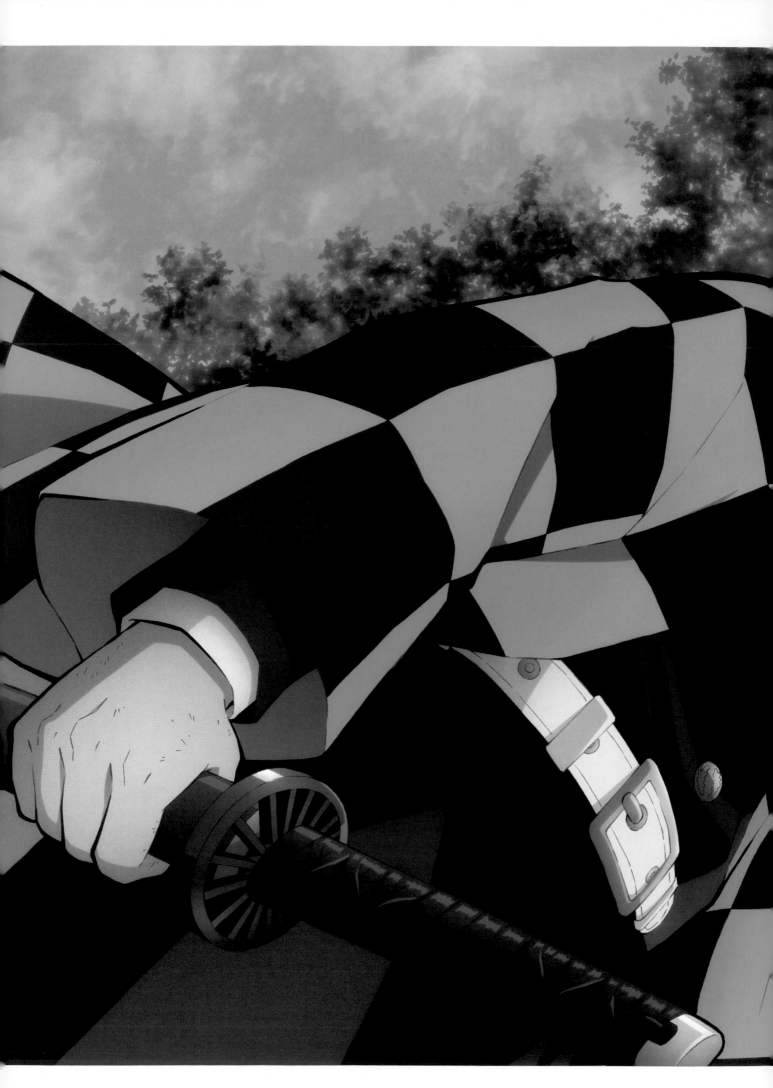

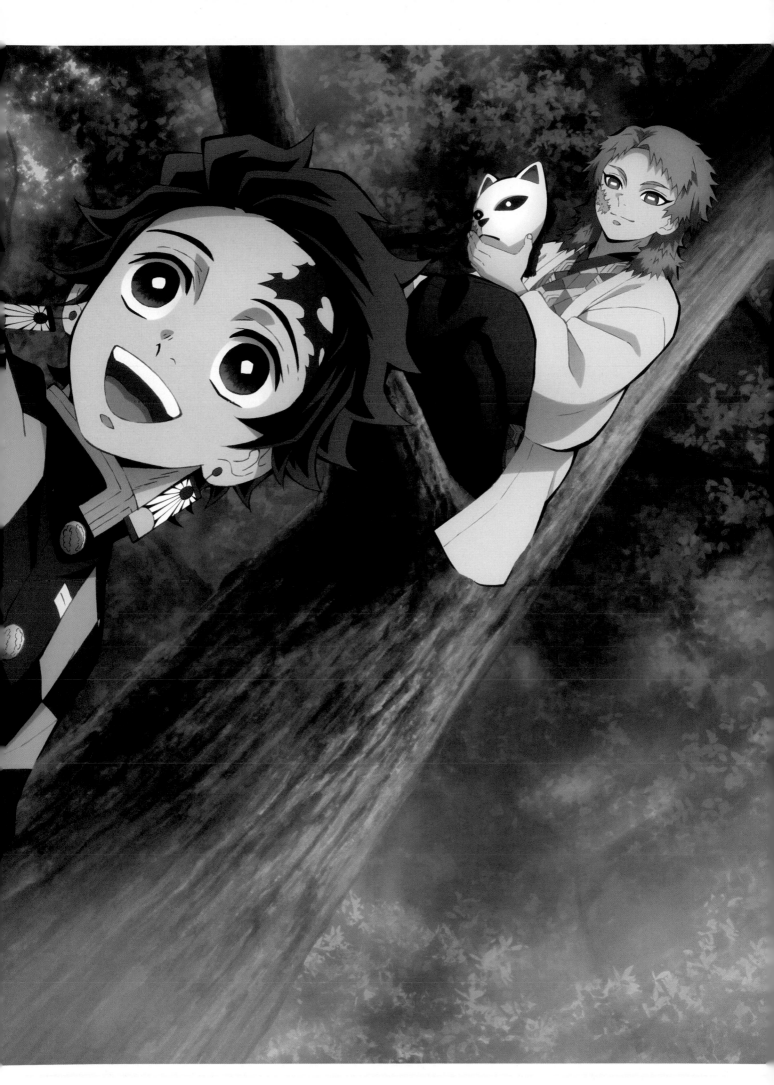

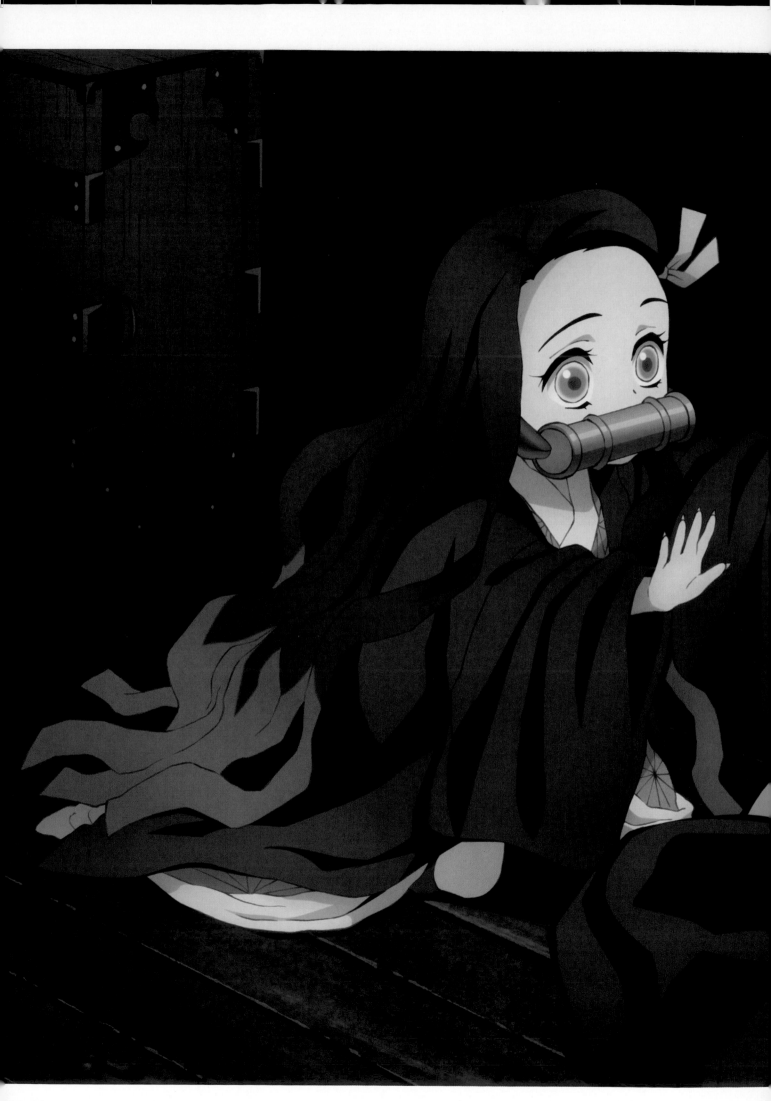

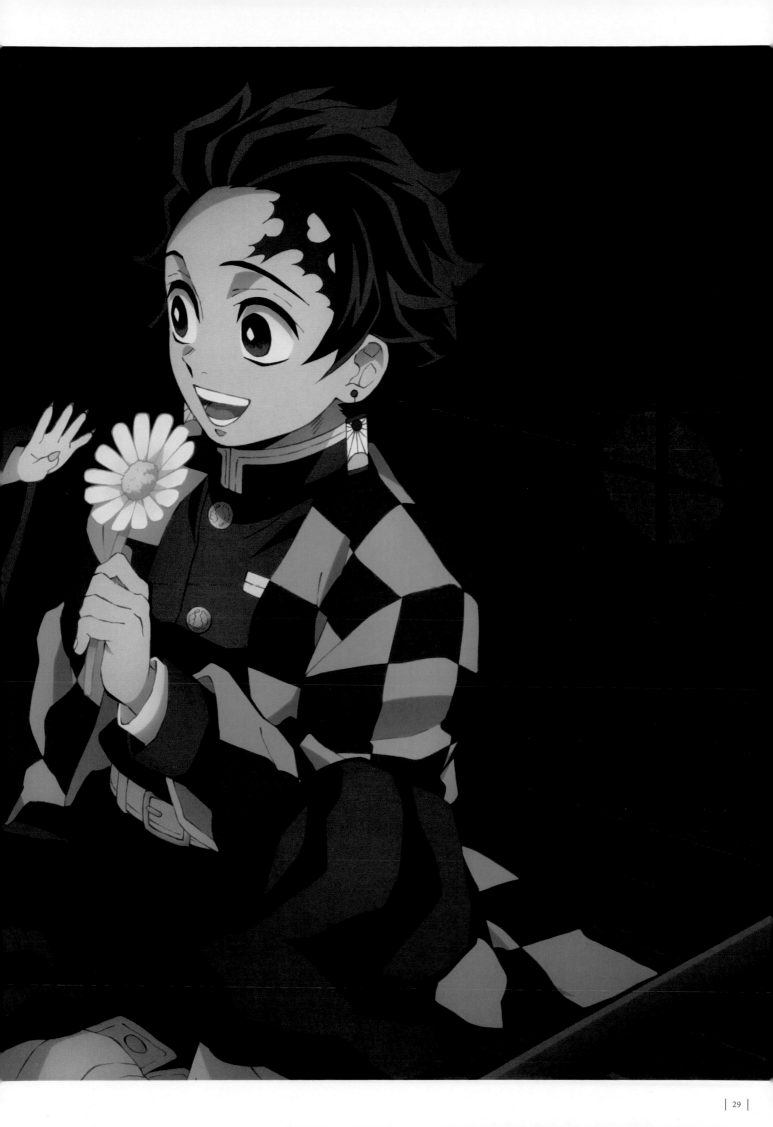

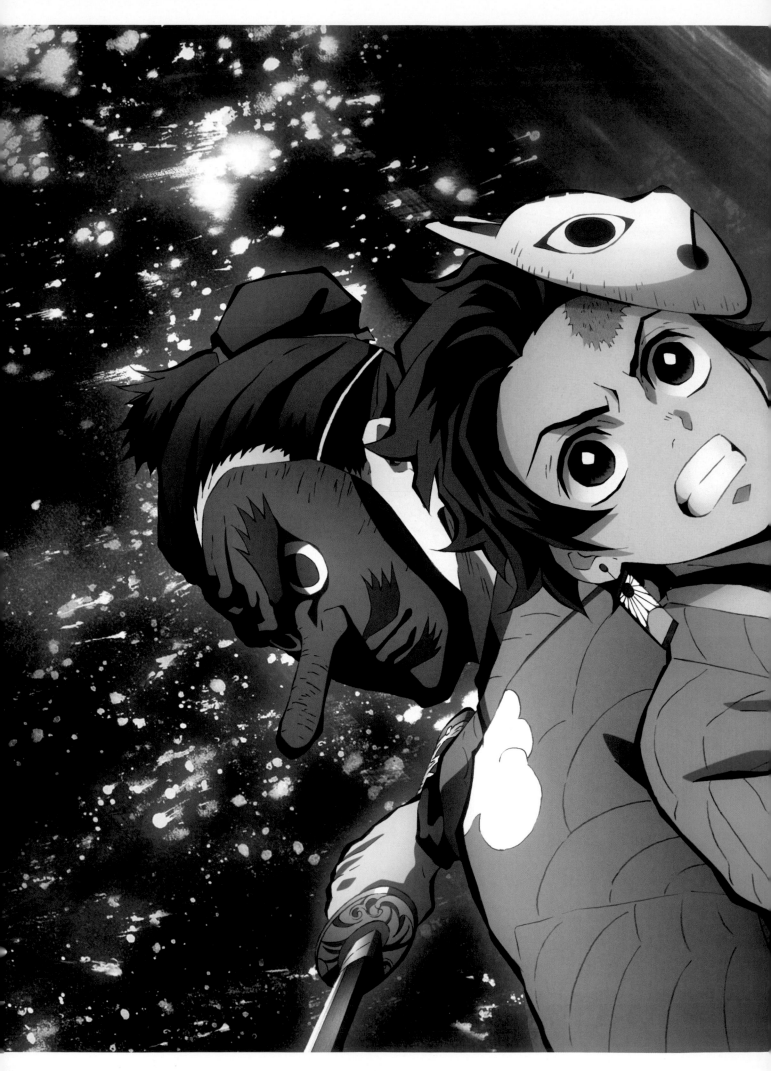

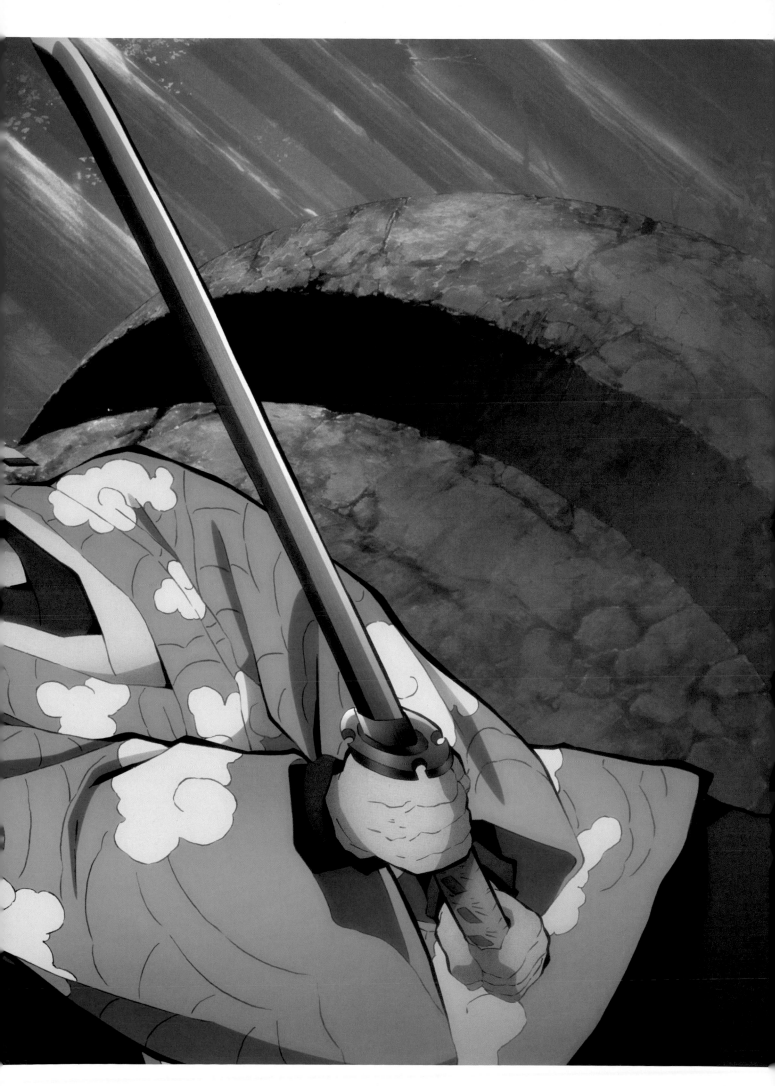

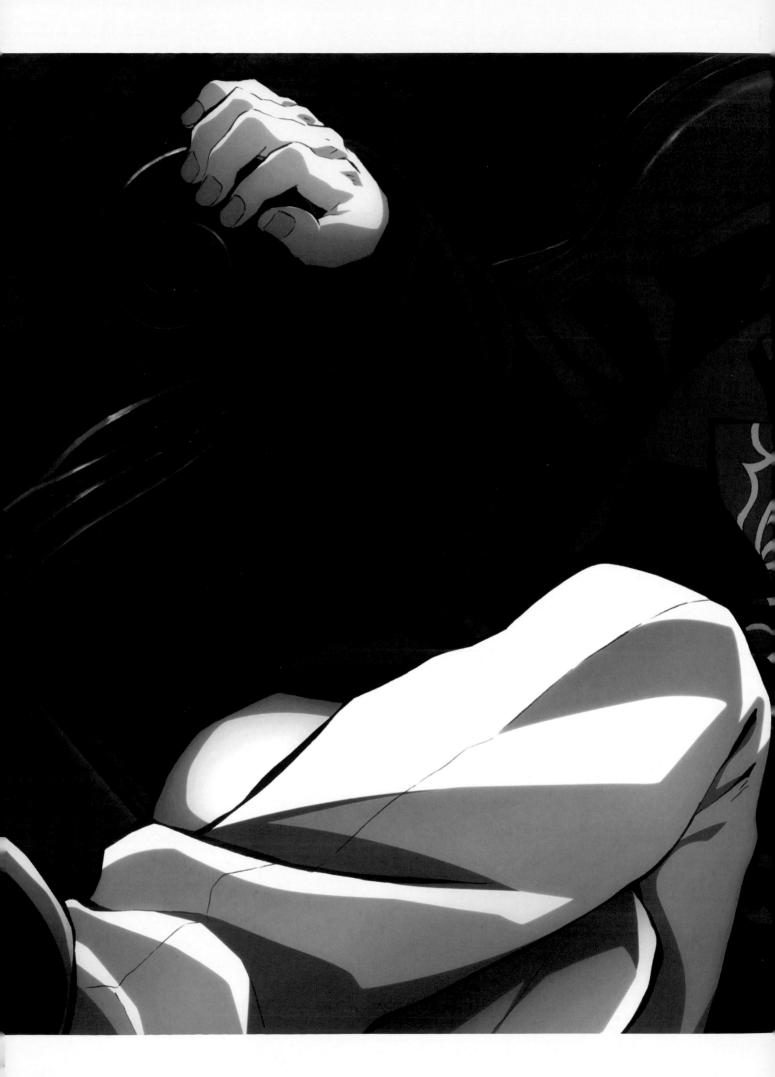

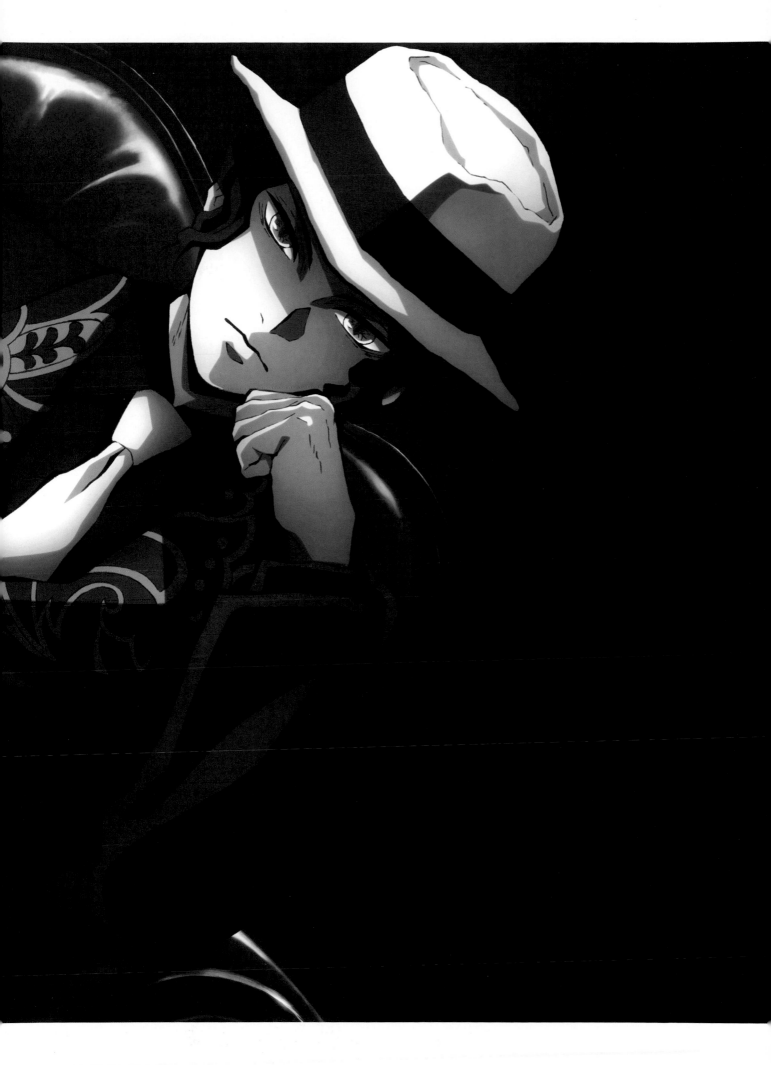

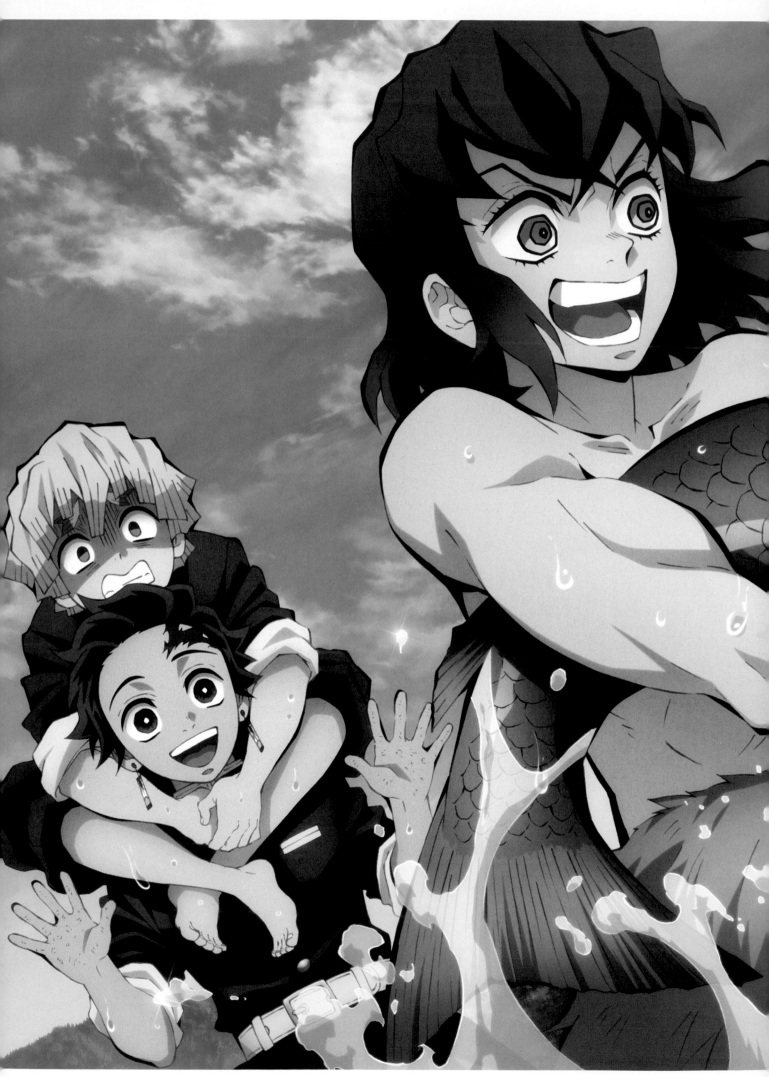

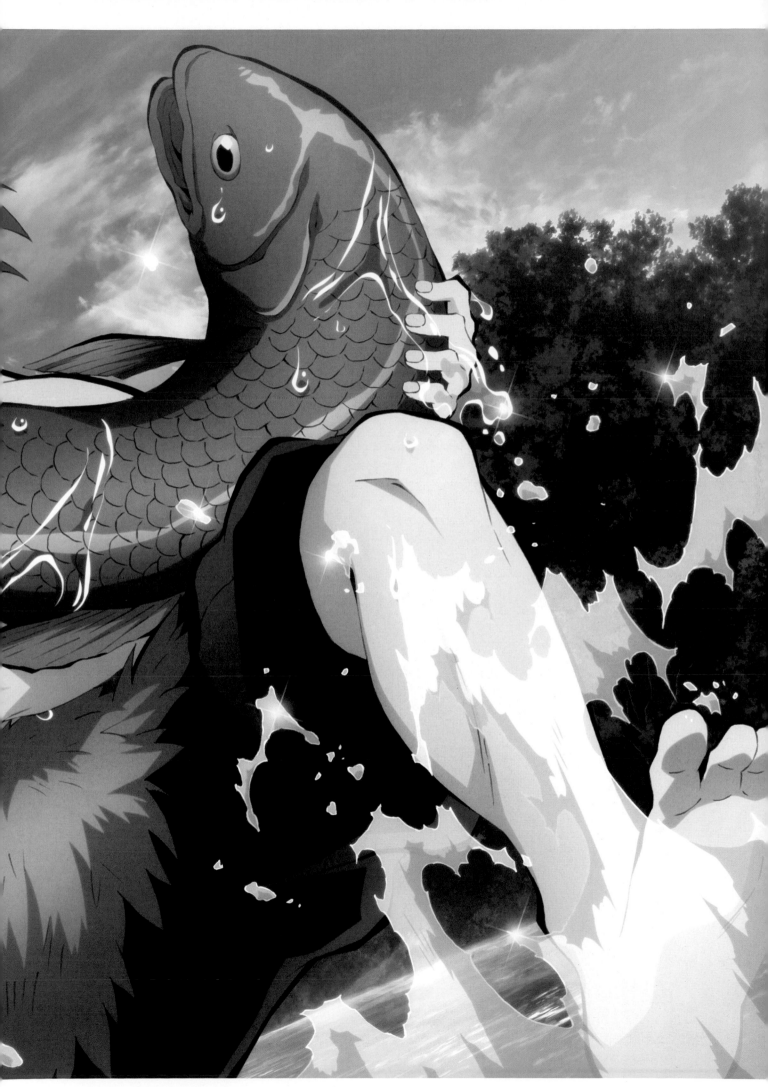

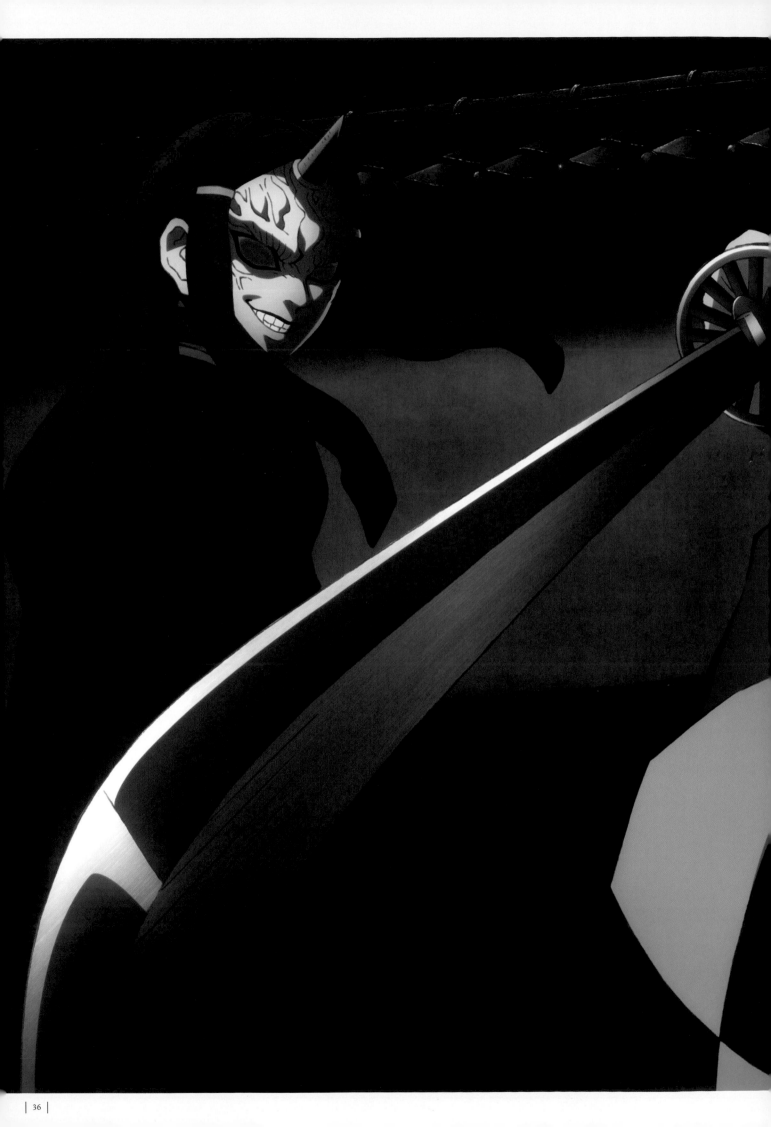

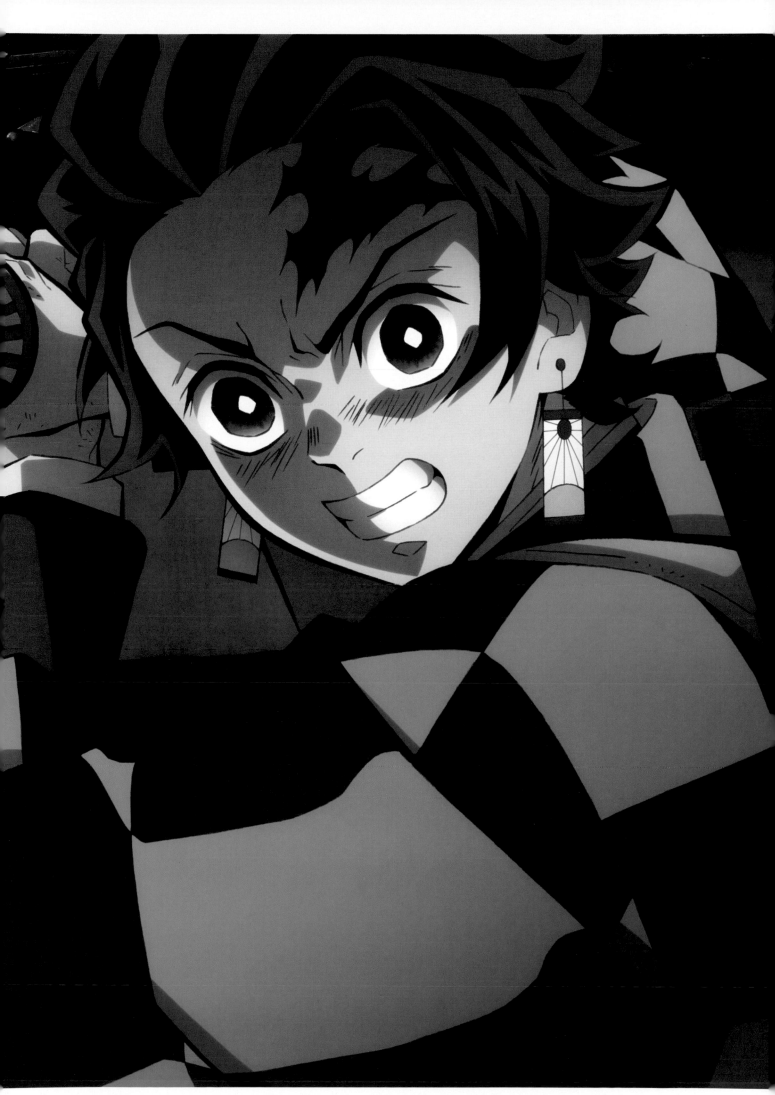

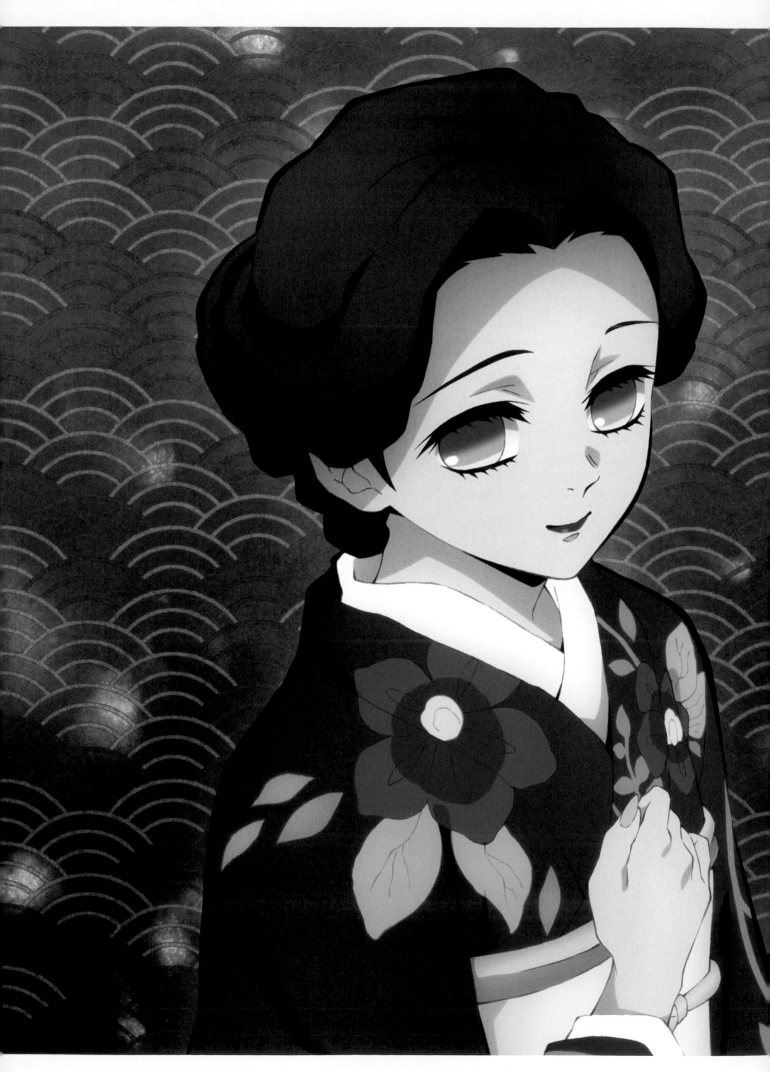

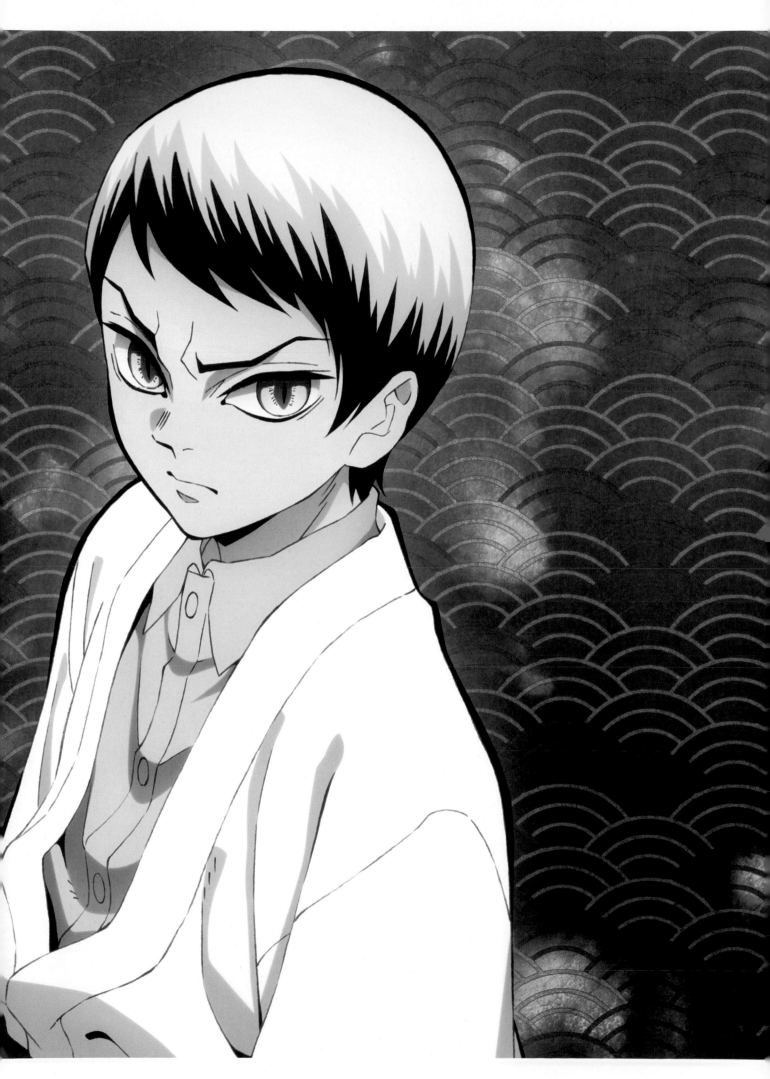

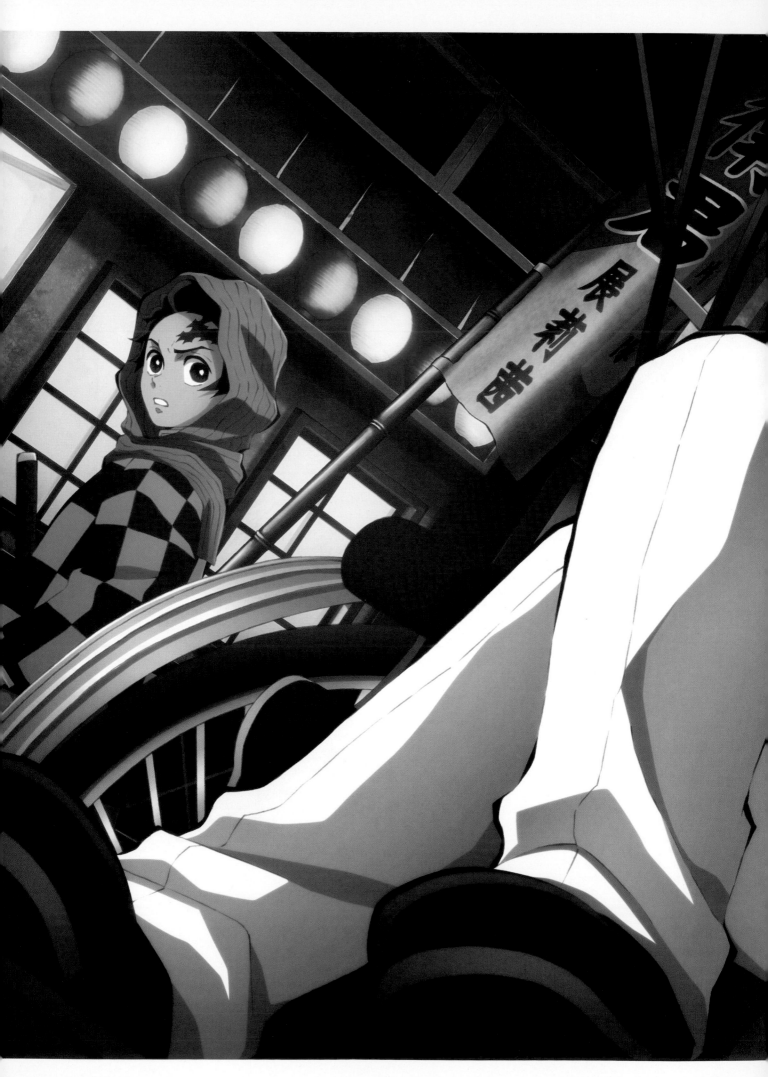

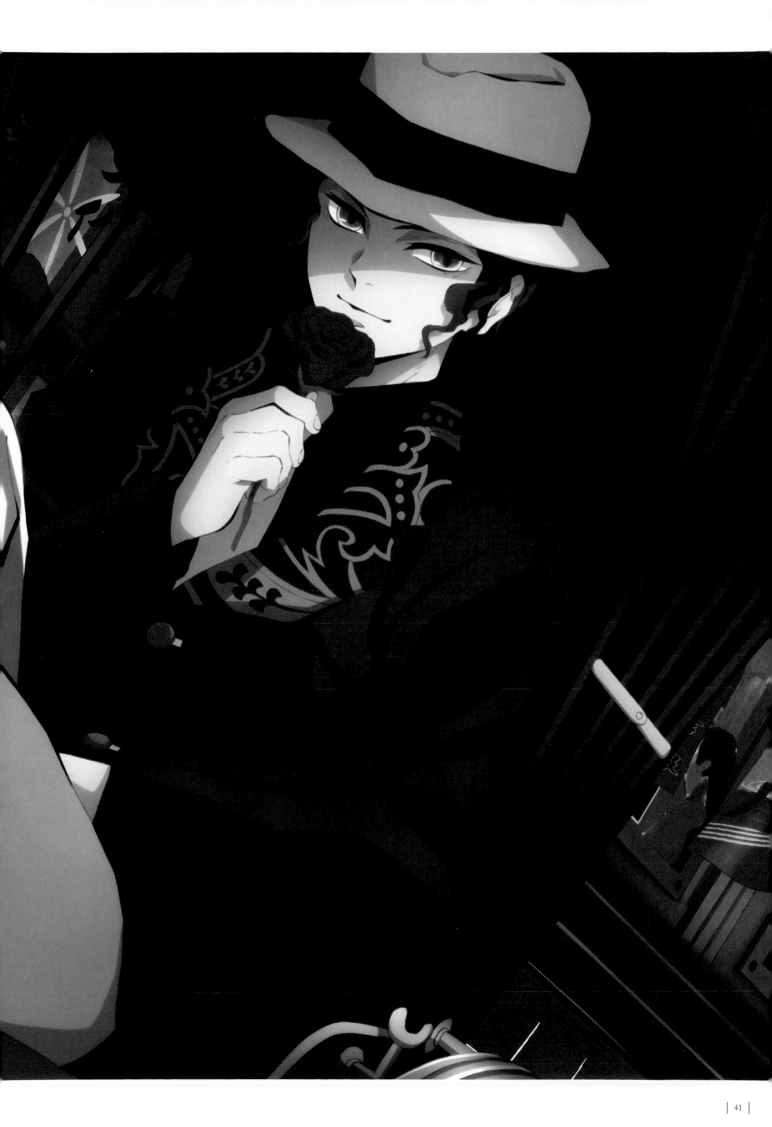

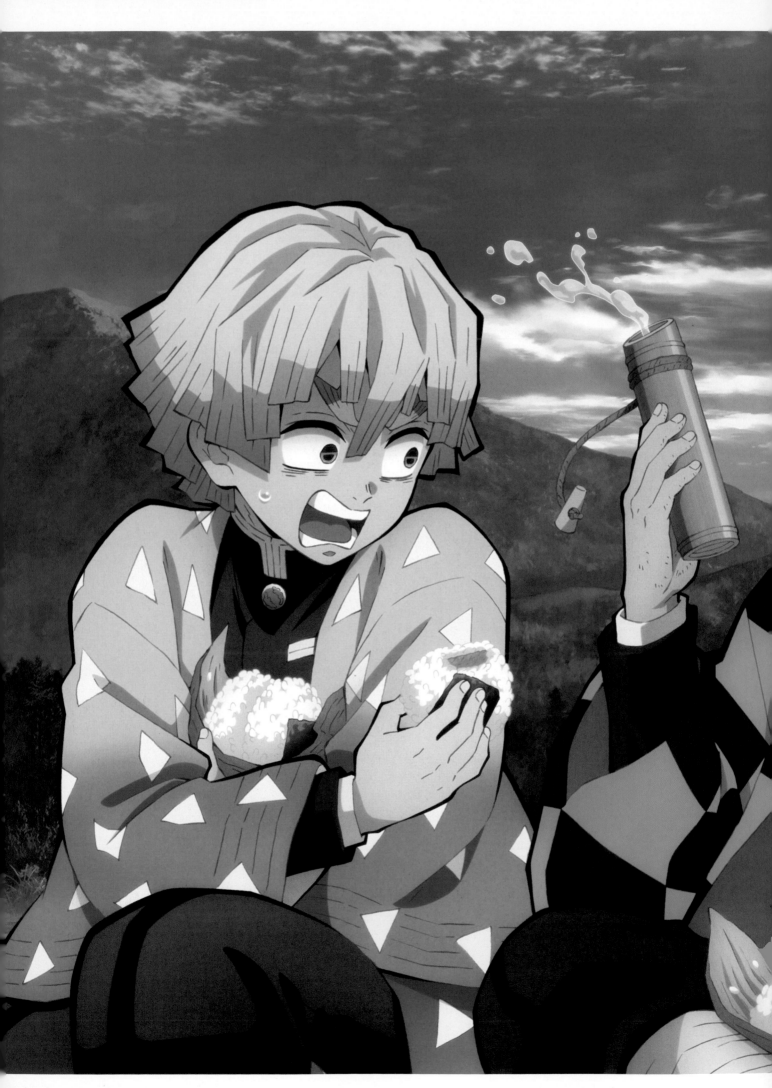

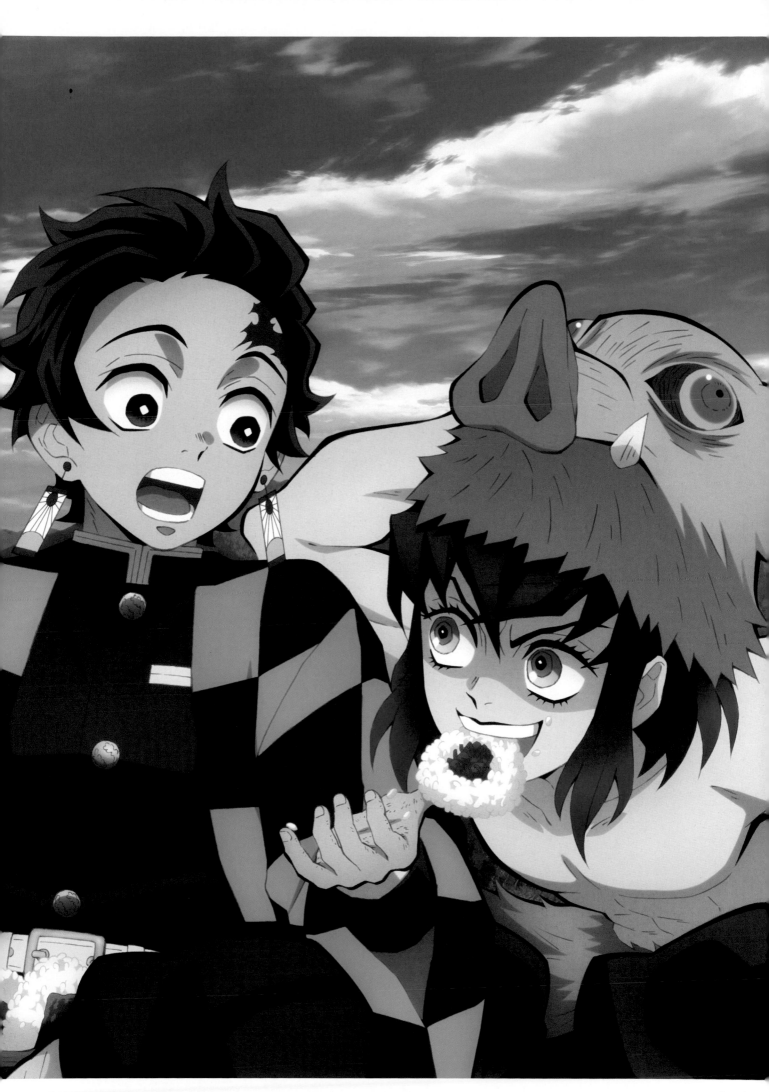

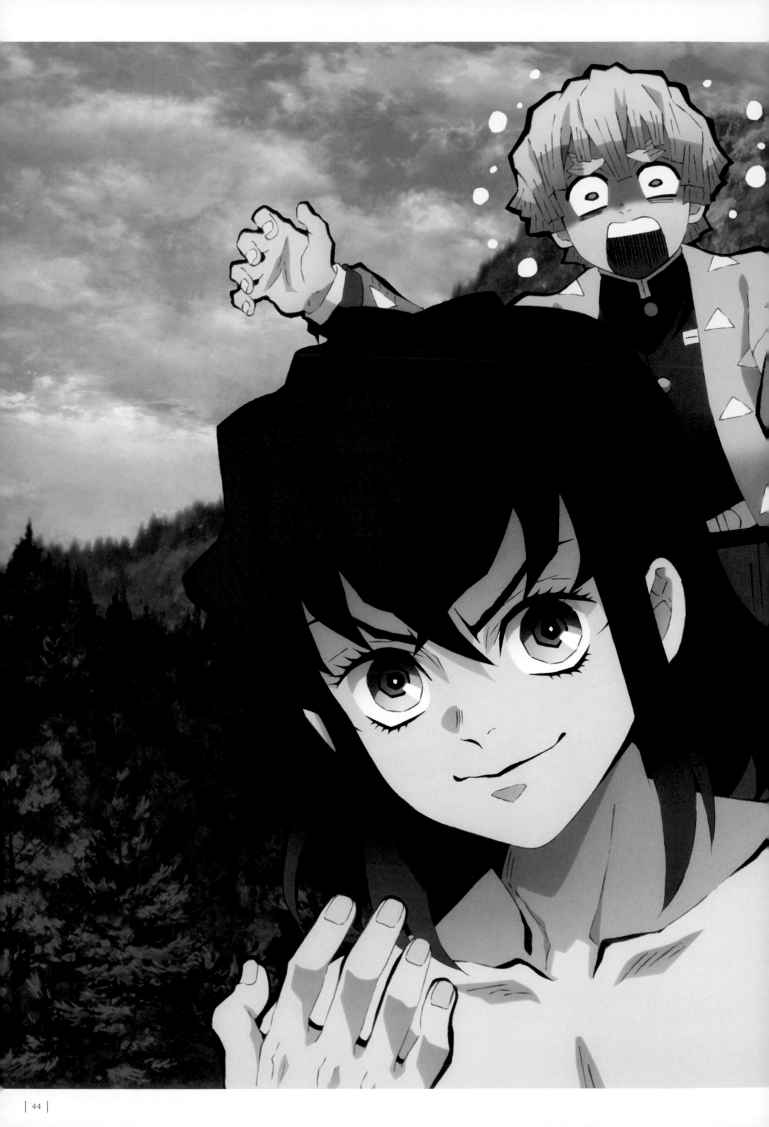

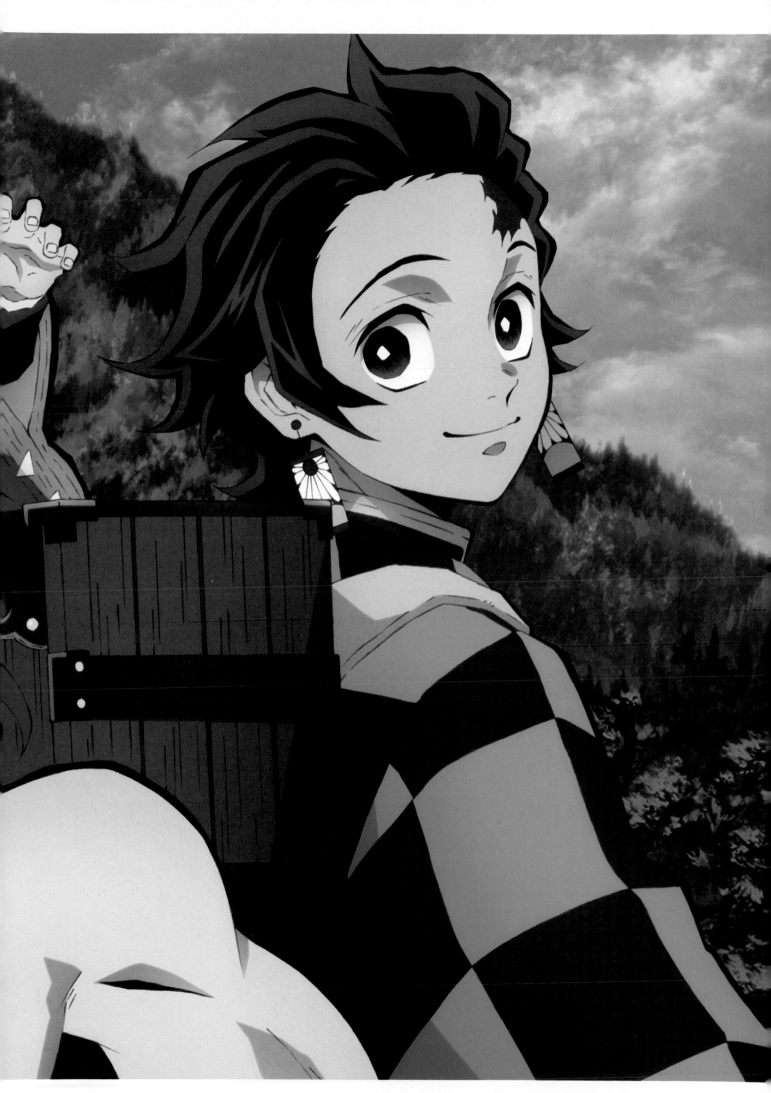

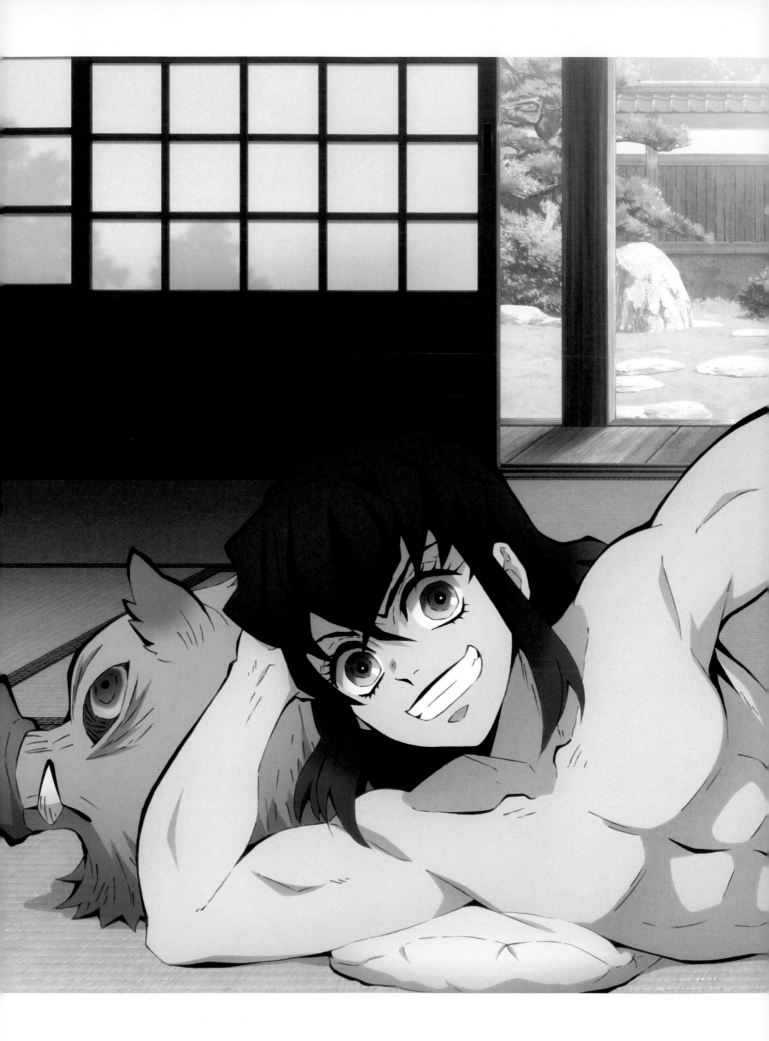

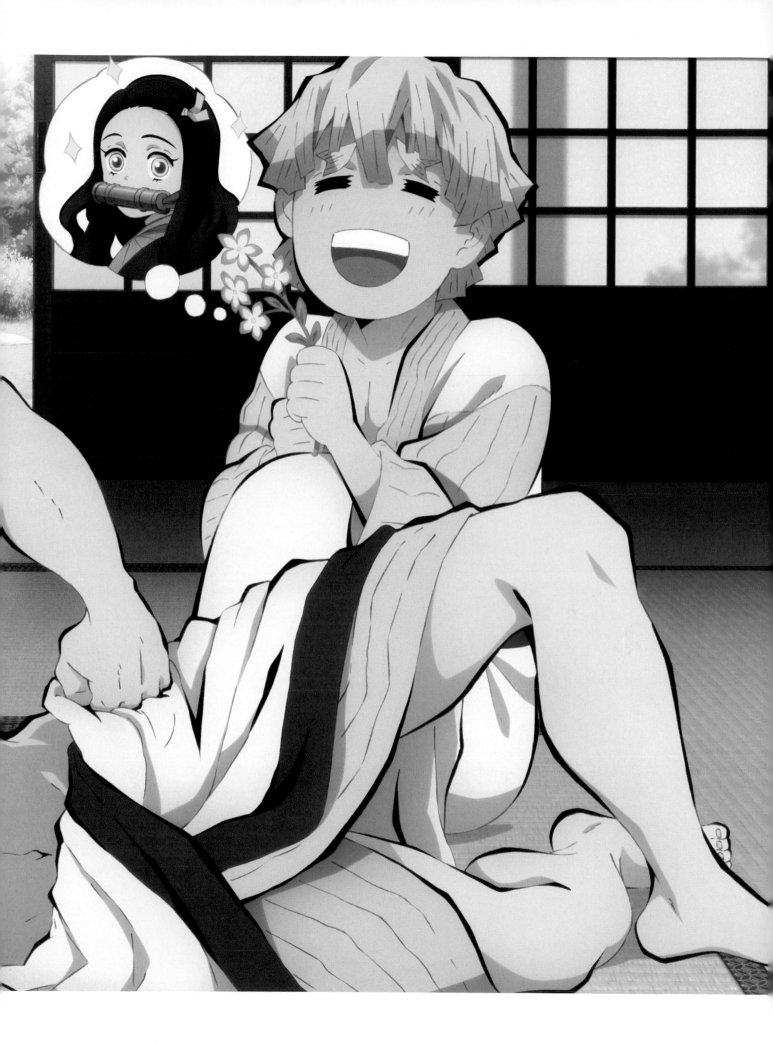

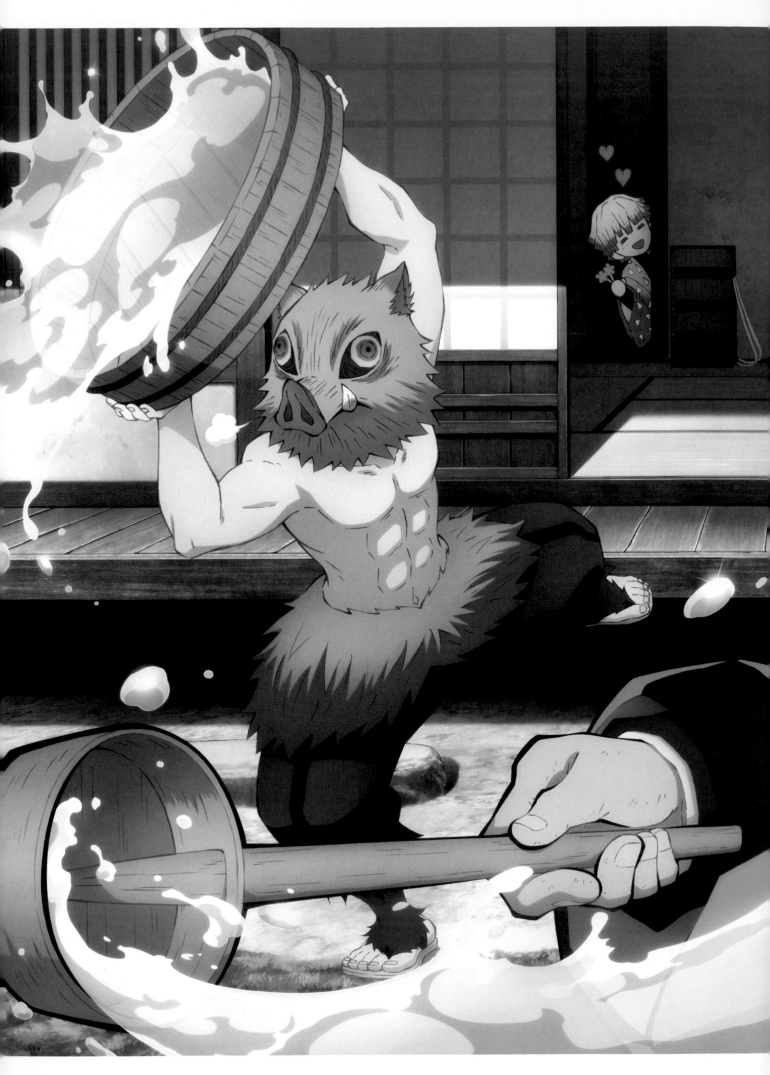

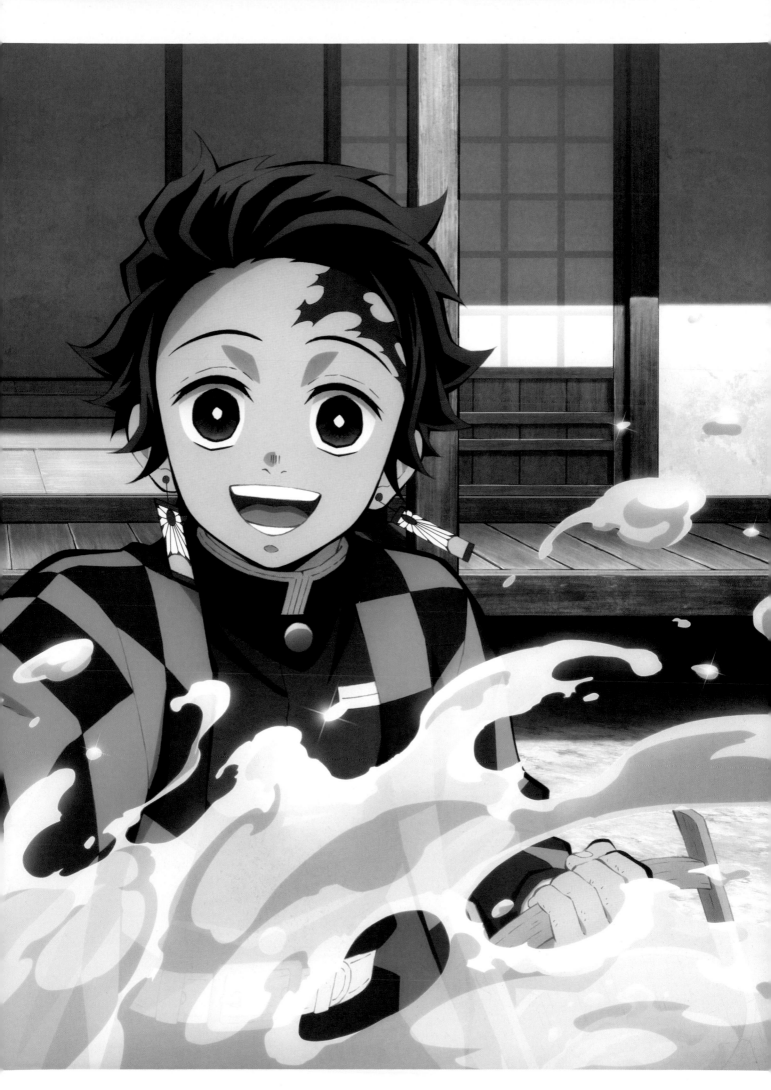

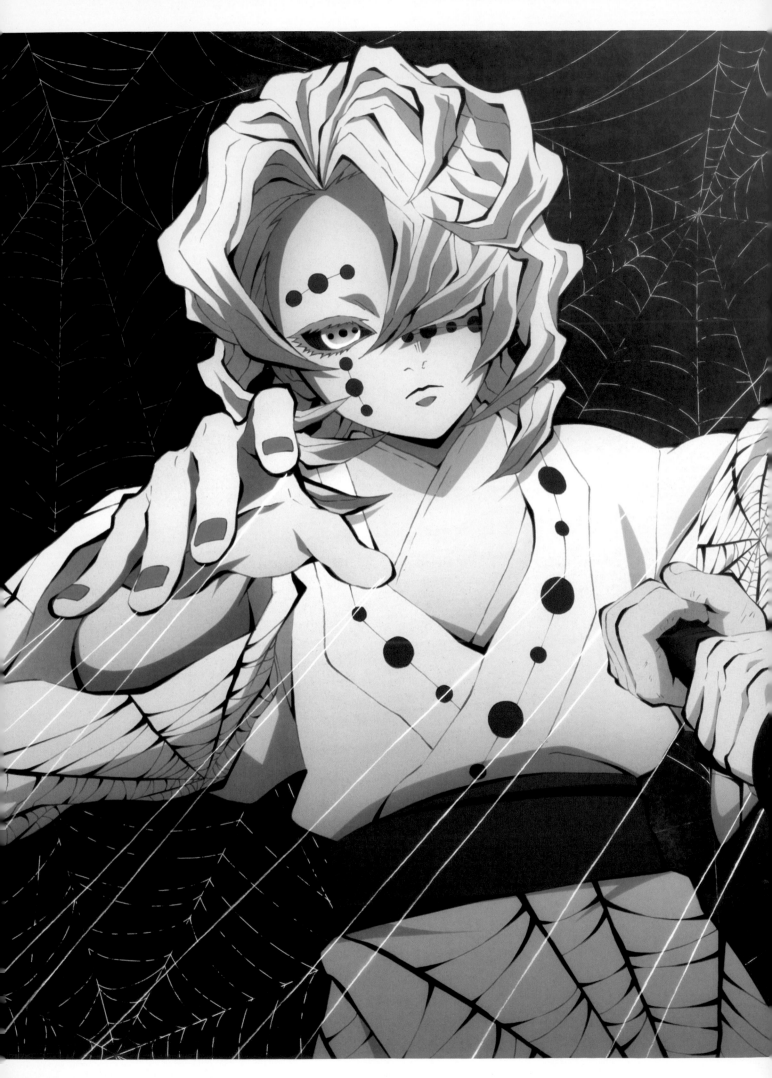

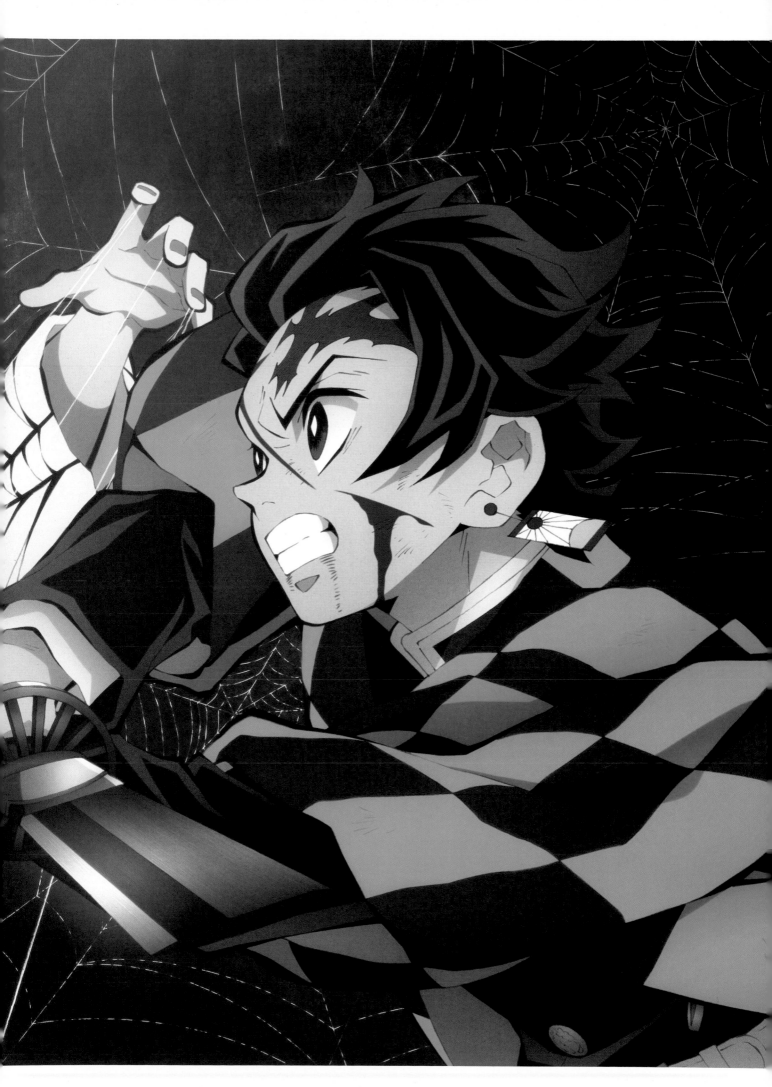

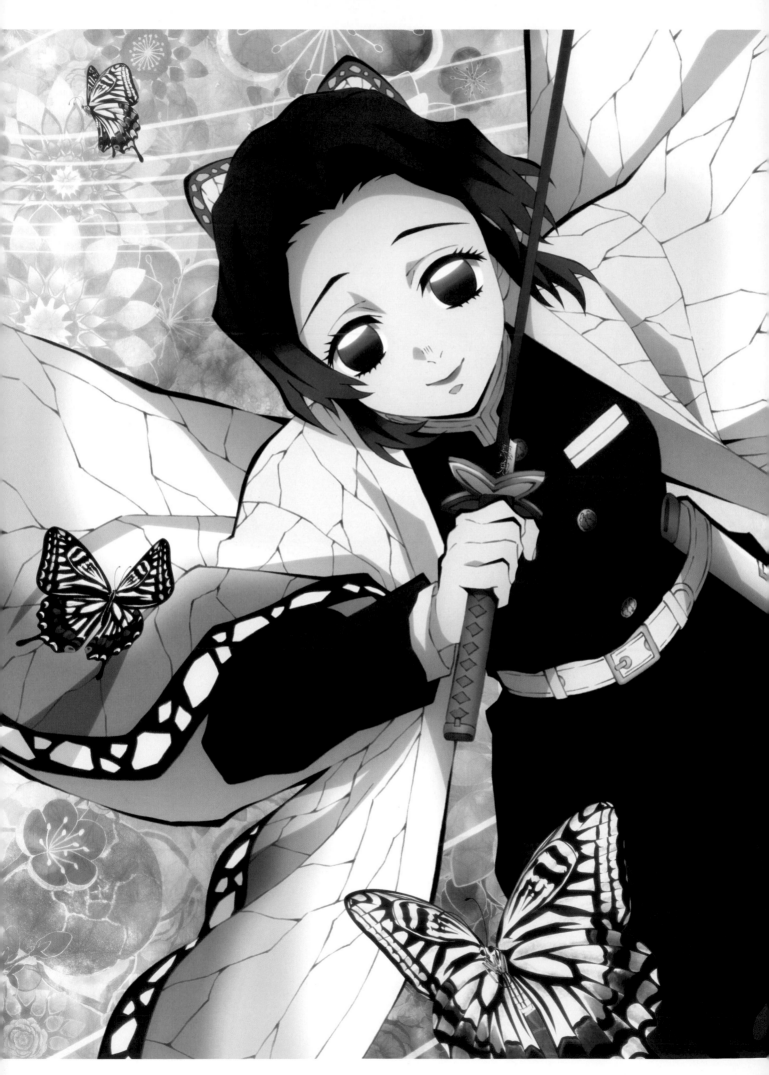

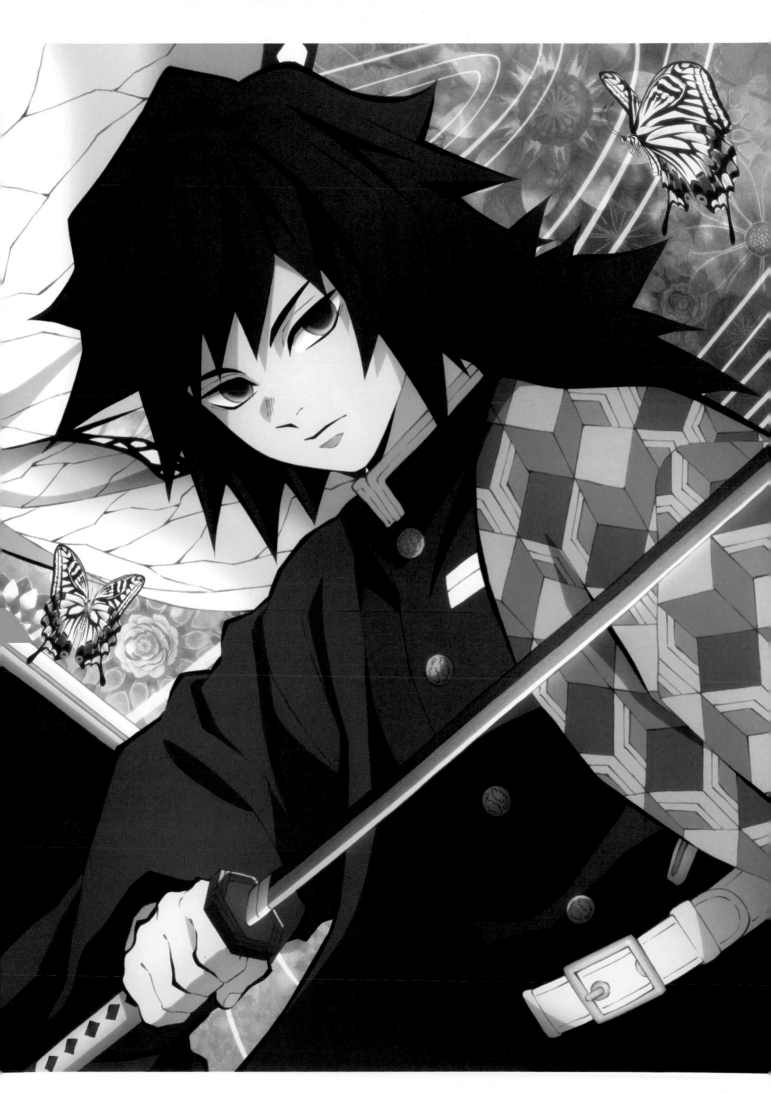

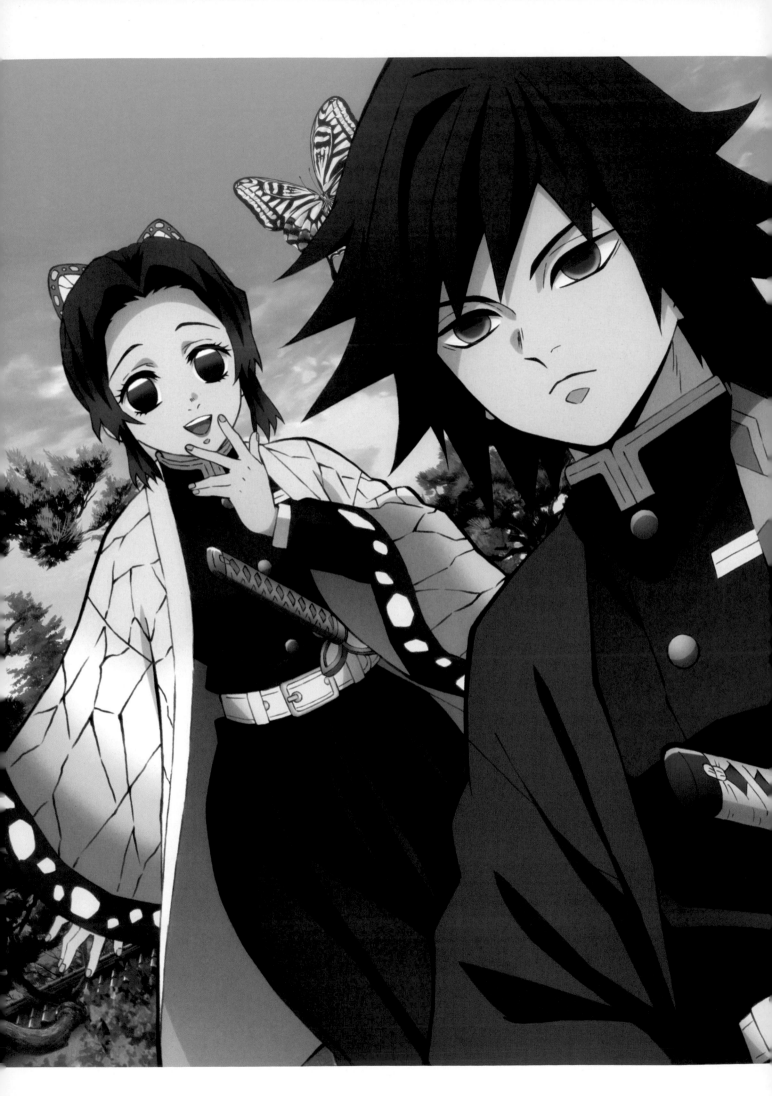

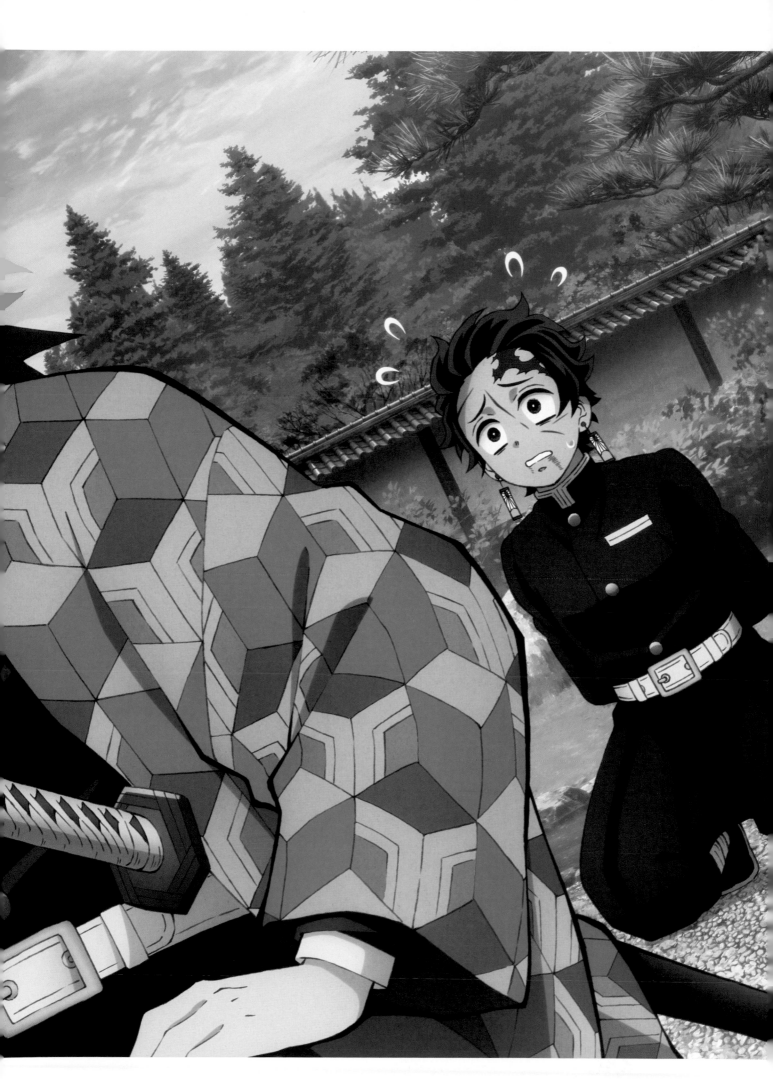

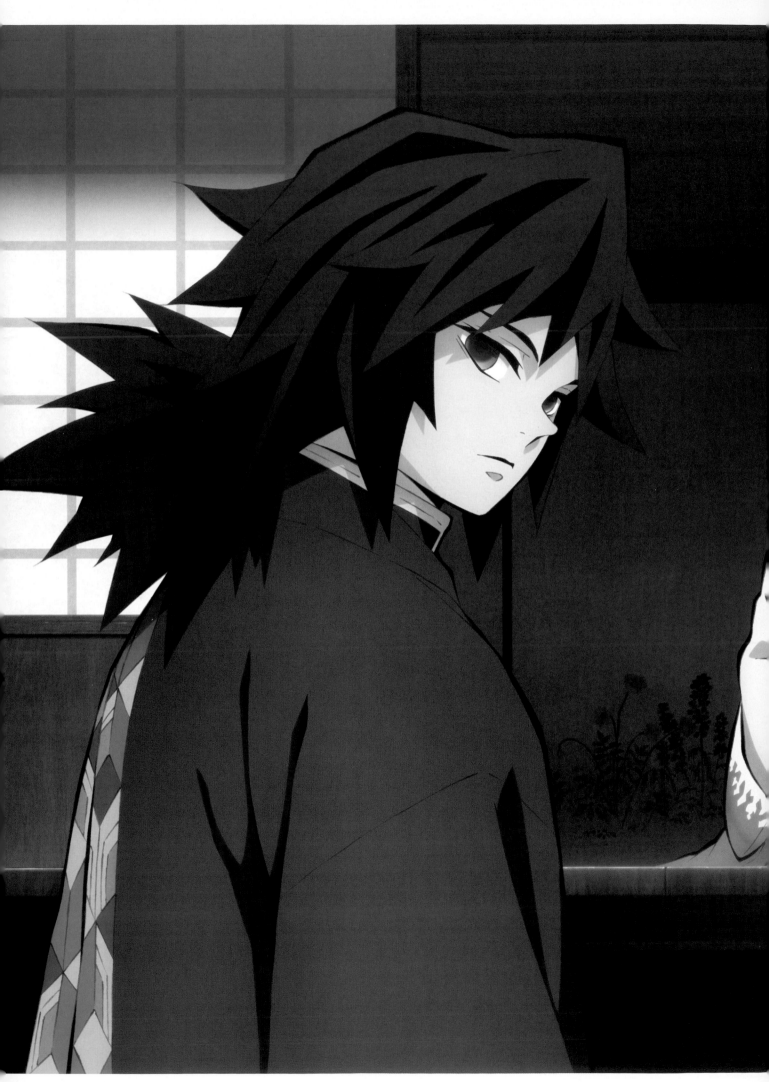

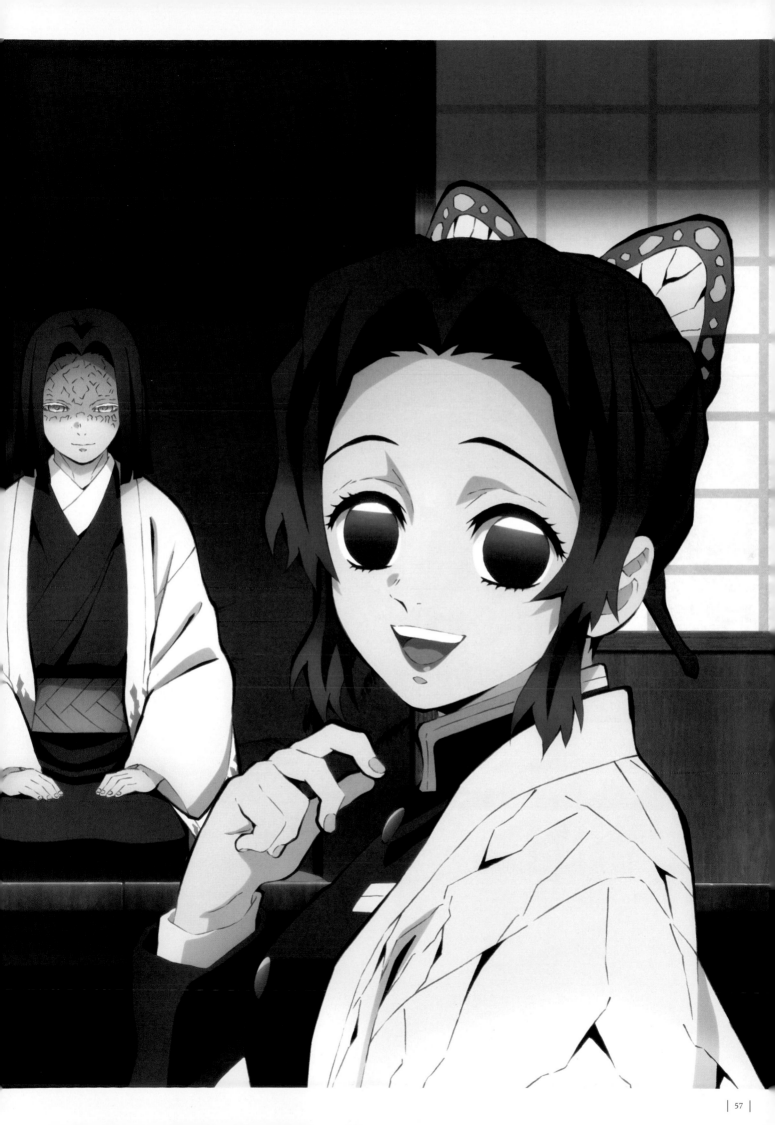

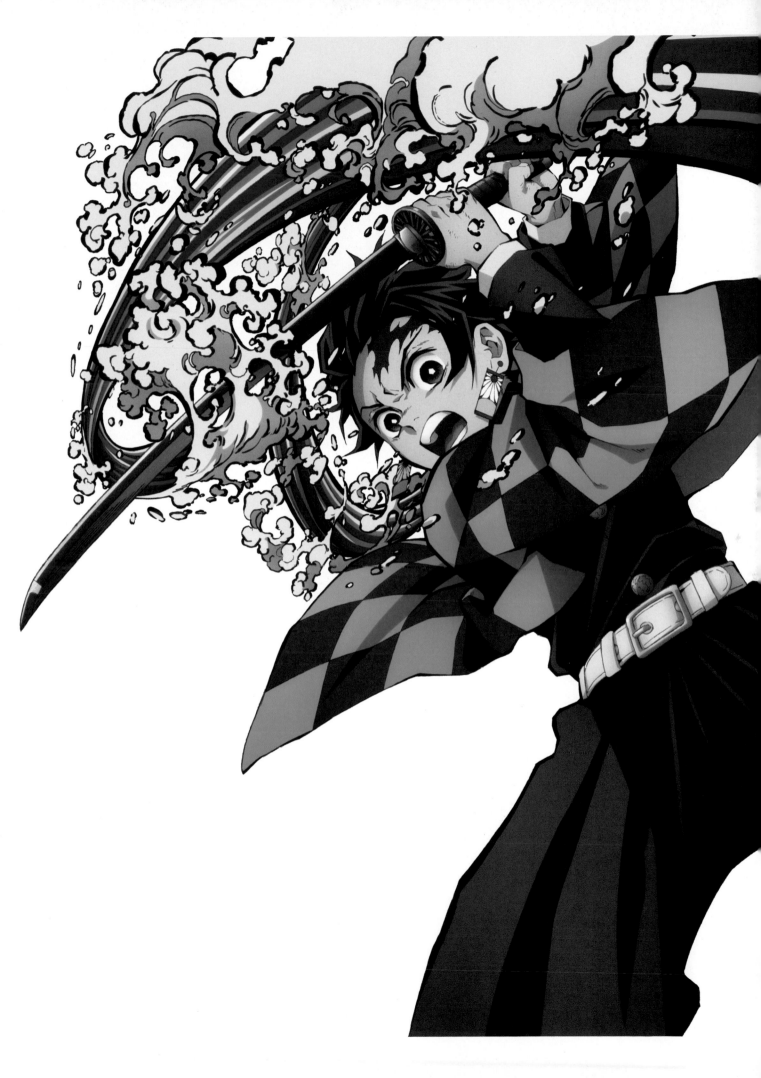

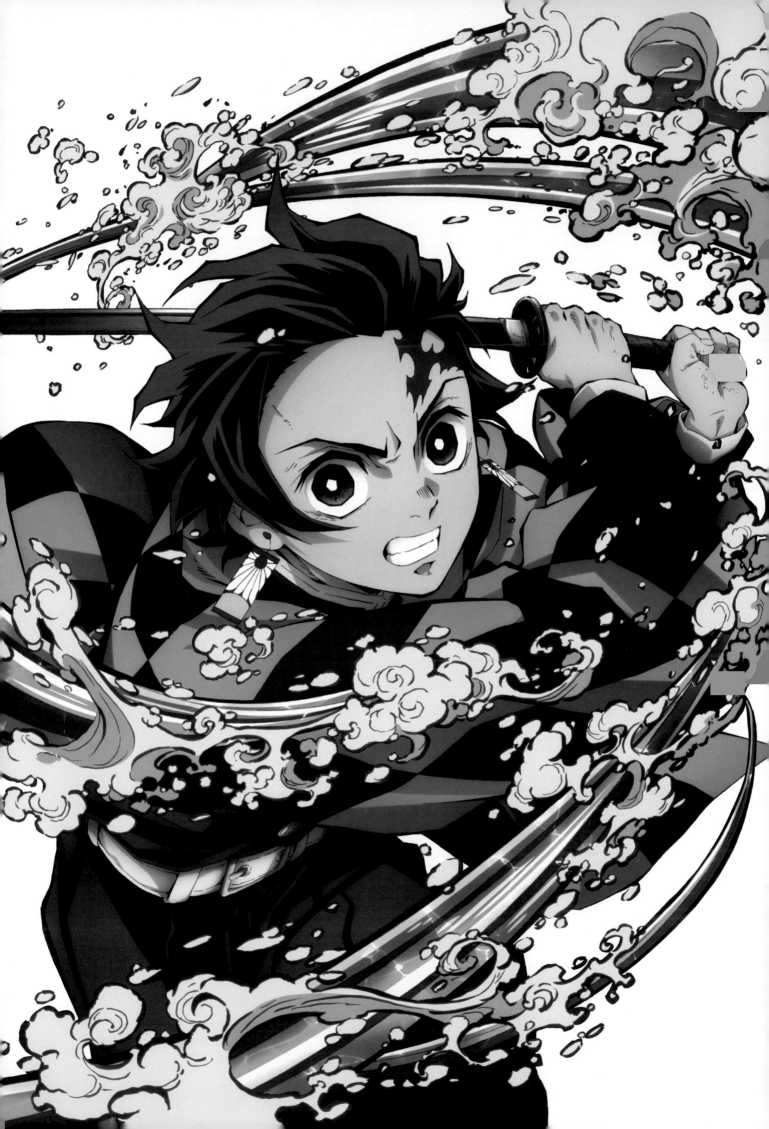

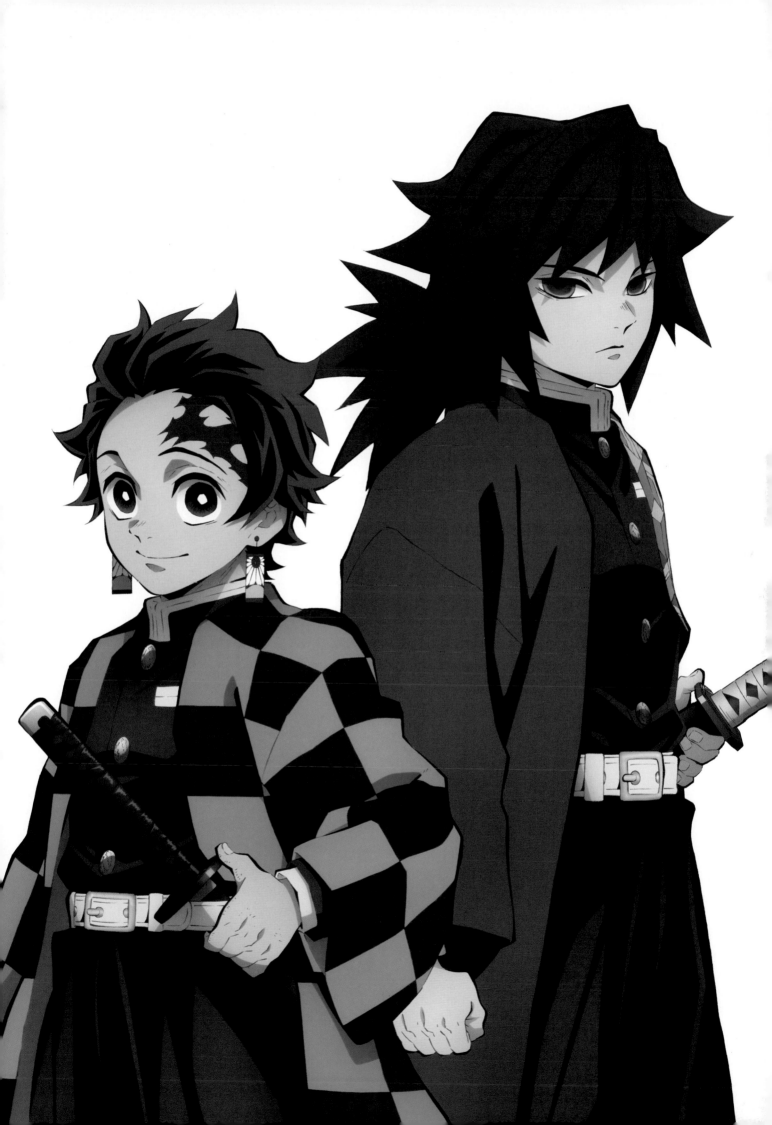

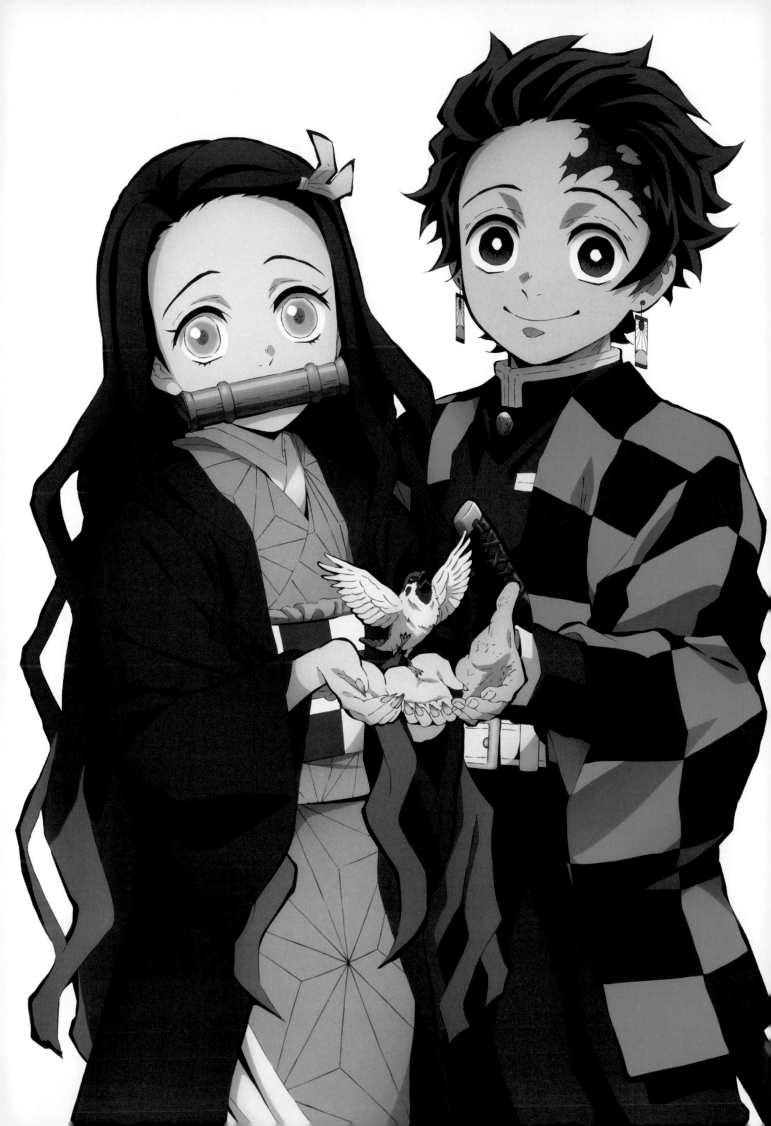

PART 3
CHARACTER ART

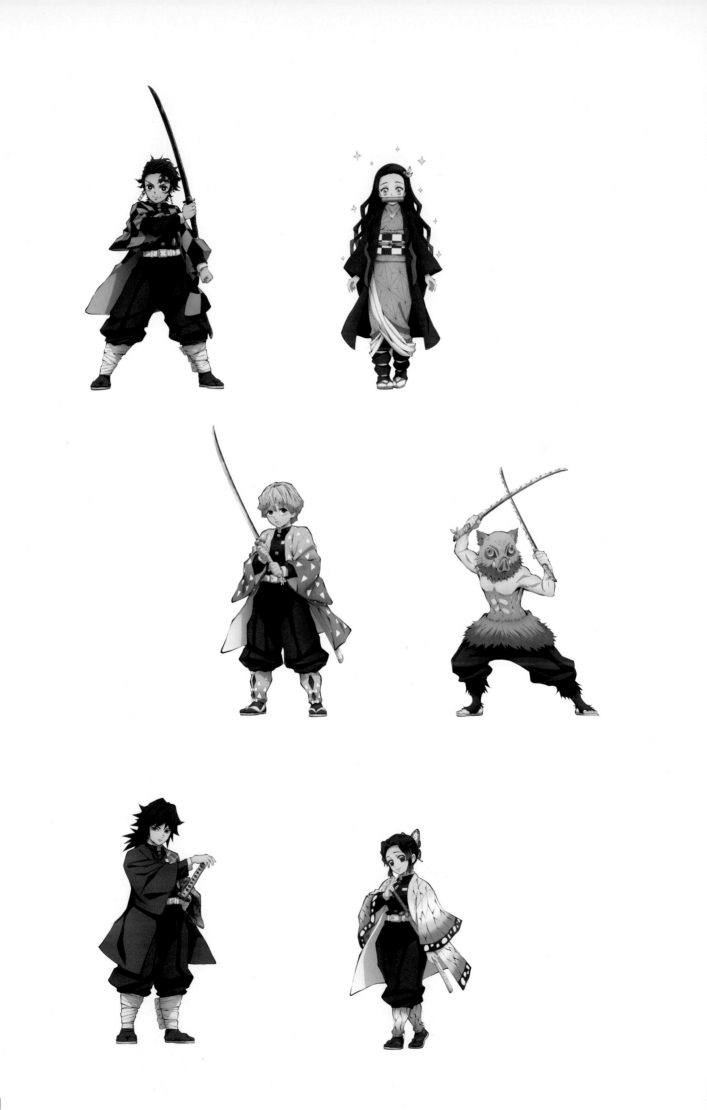

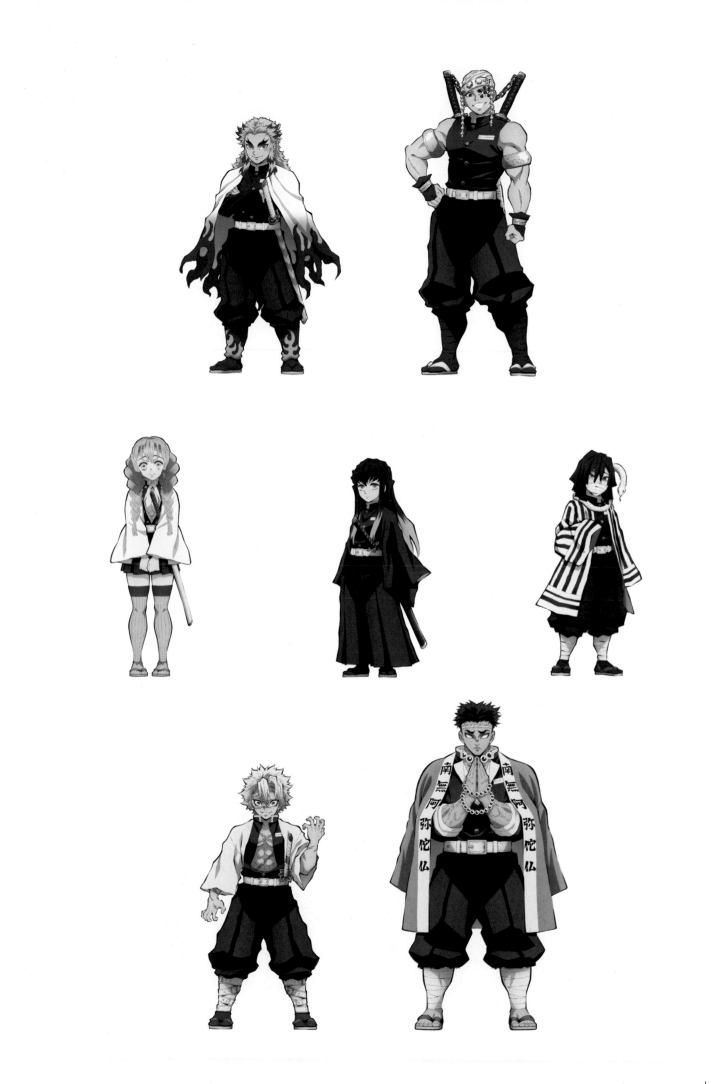

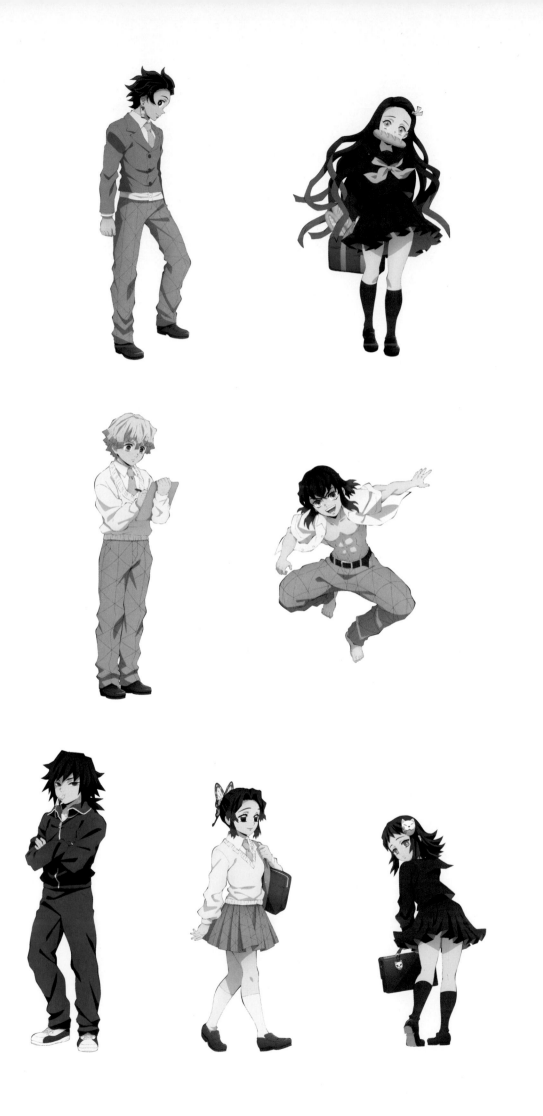

PART 4
THEATRICAL & EVENTS

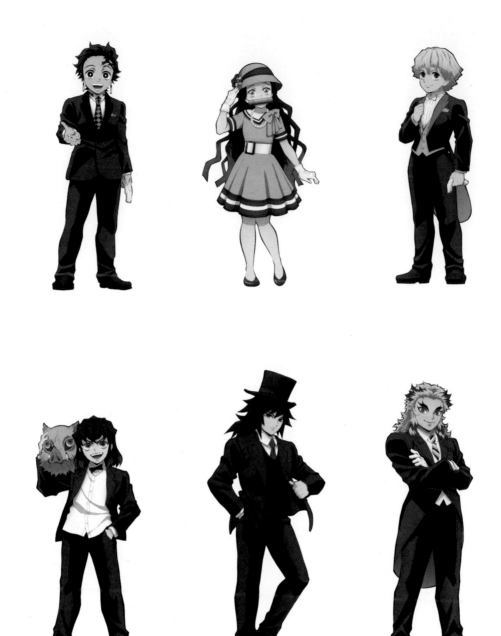

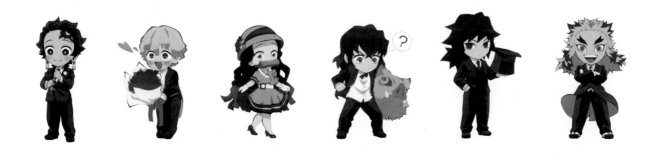

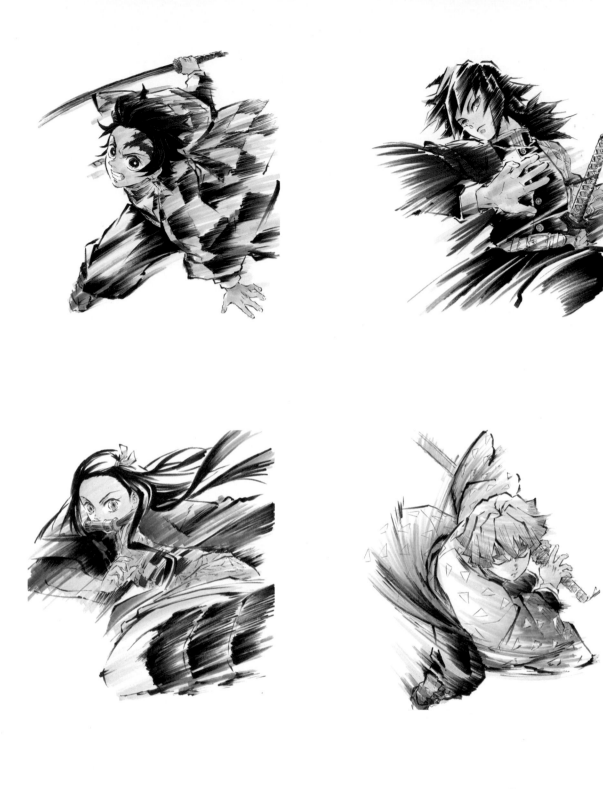

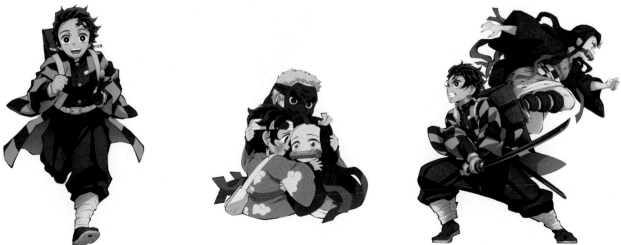

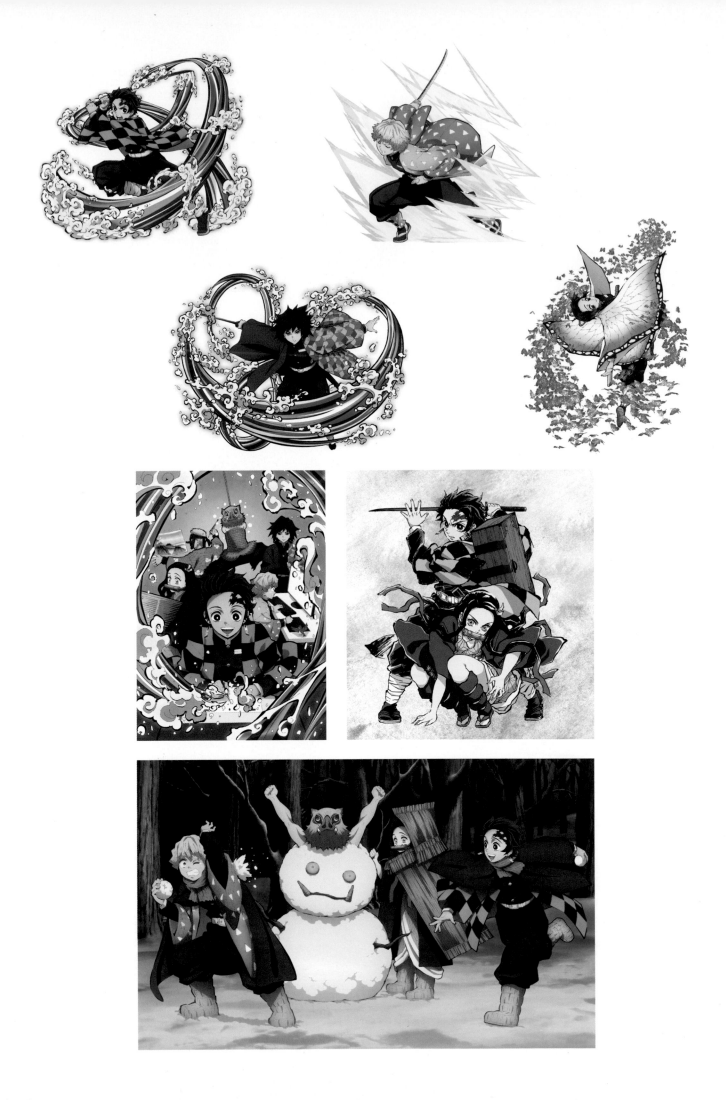

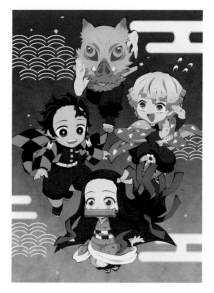

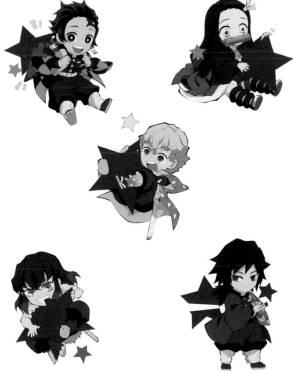

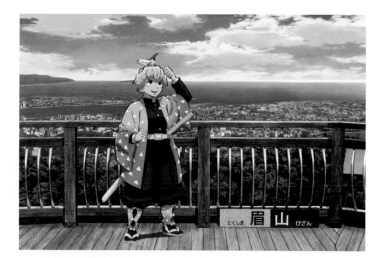

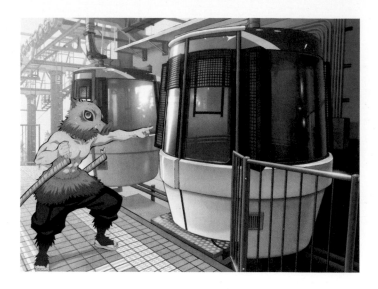

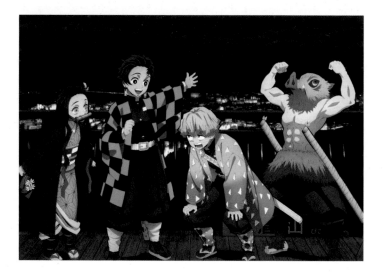

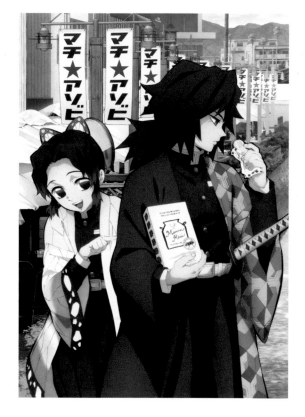

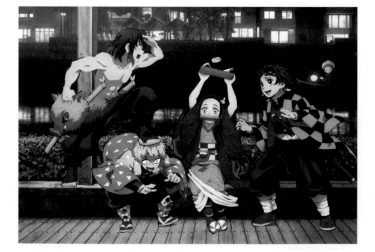

PART 5
SEASONAL

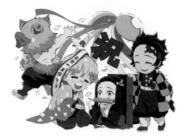

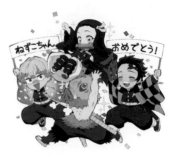

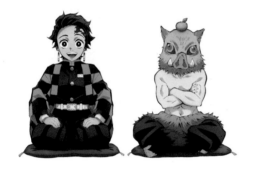

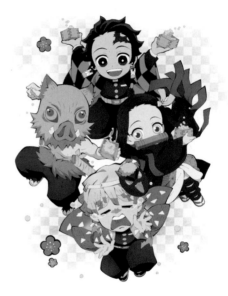

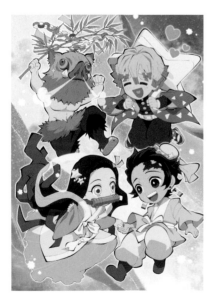

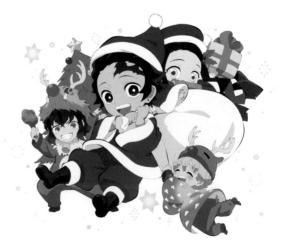

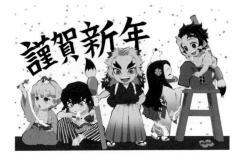

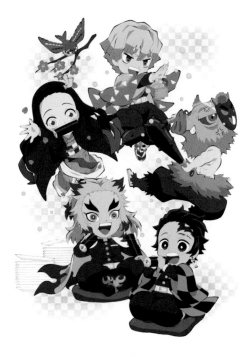

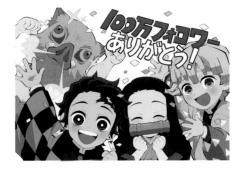

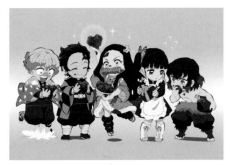

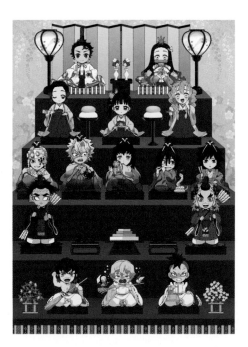

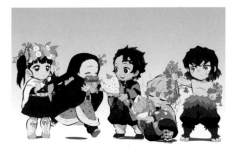

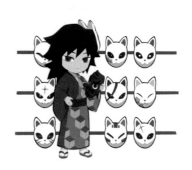

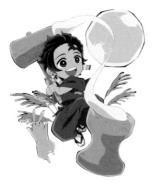

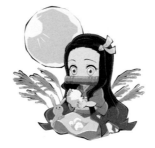

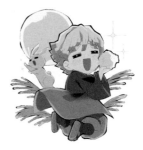

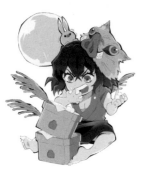

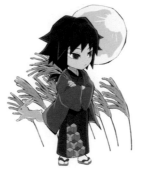

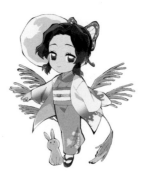

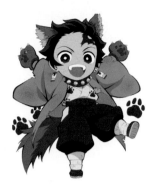

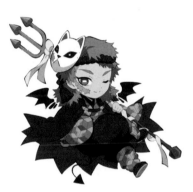
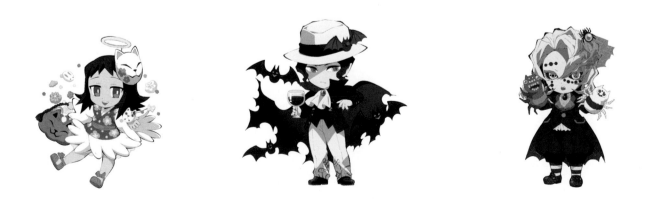

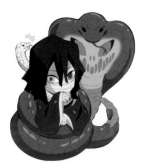
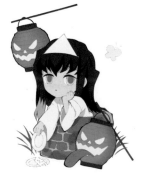
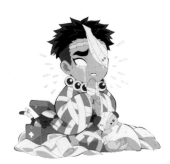

PART 6
COLLABORATIONS & GAMES

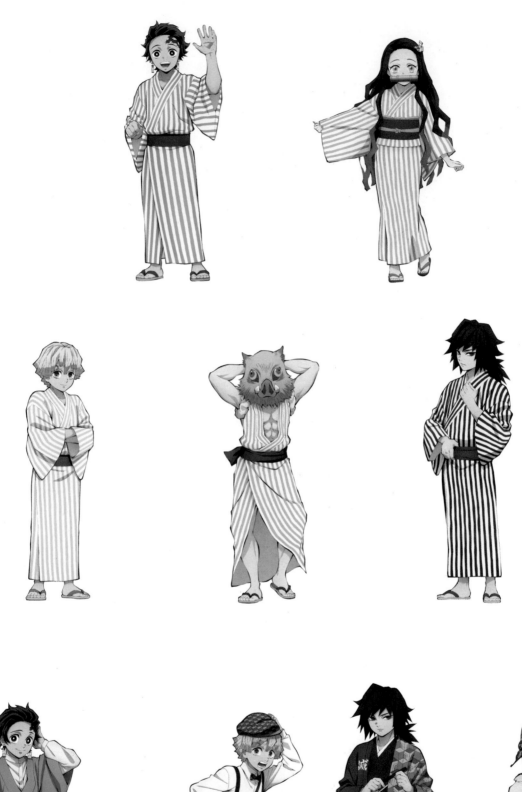

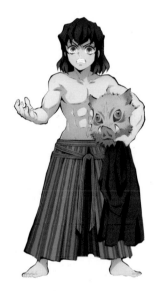

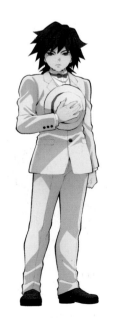

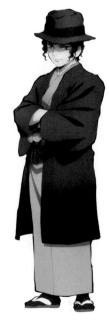

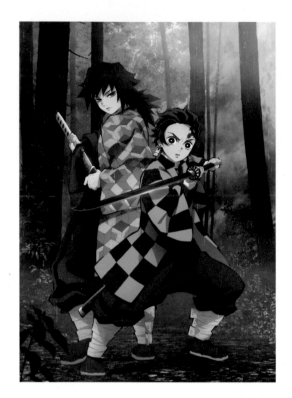

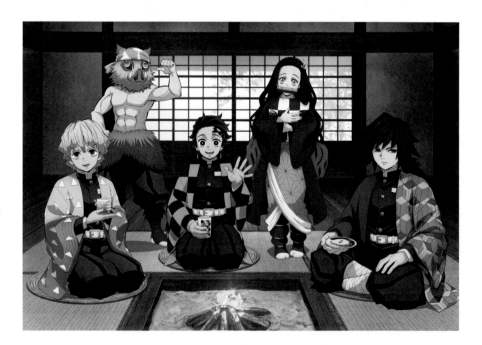

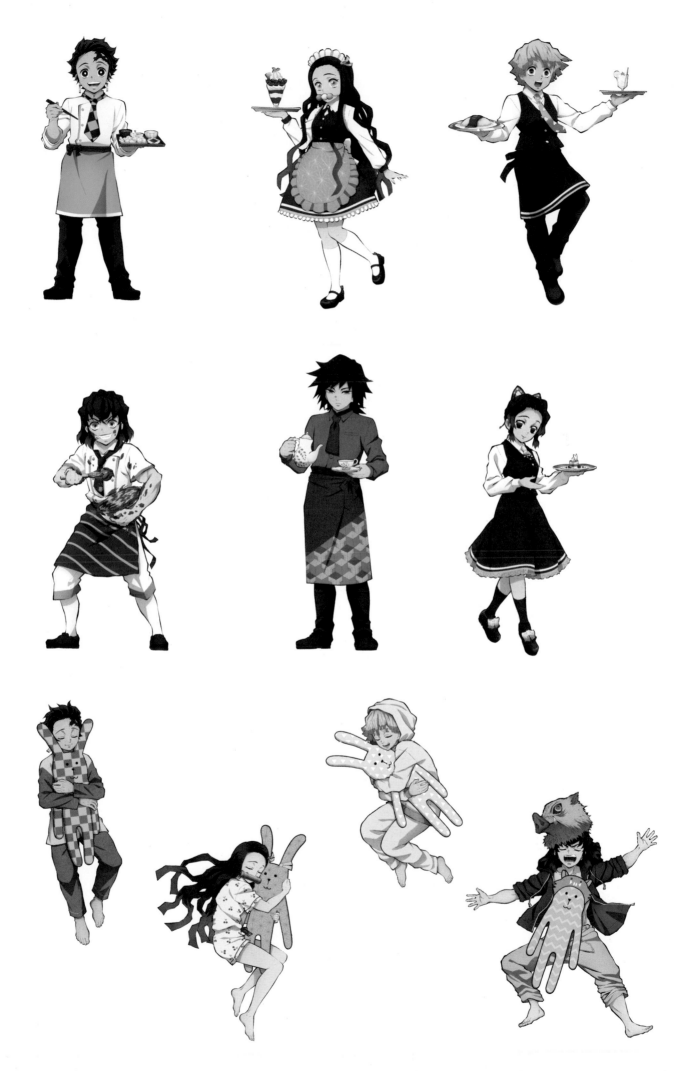

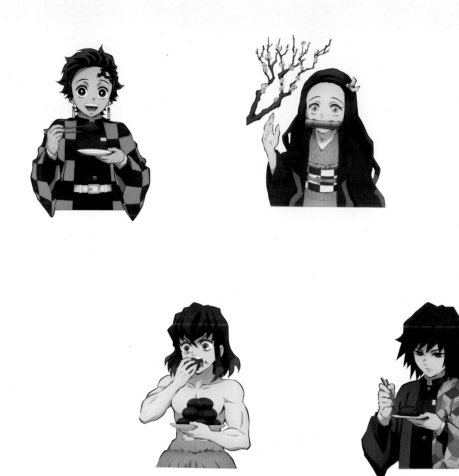

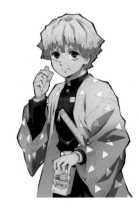

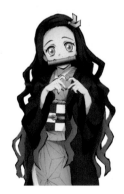

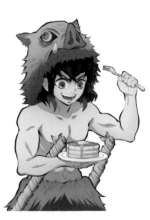

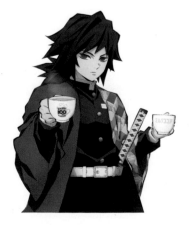

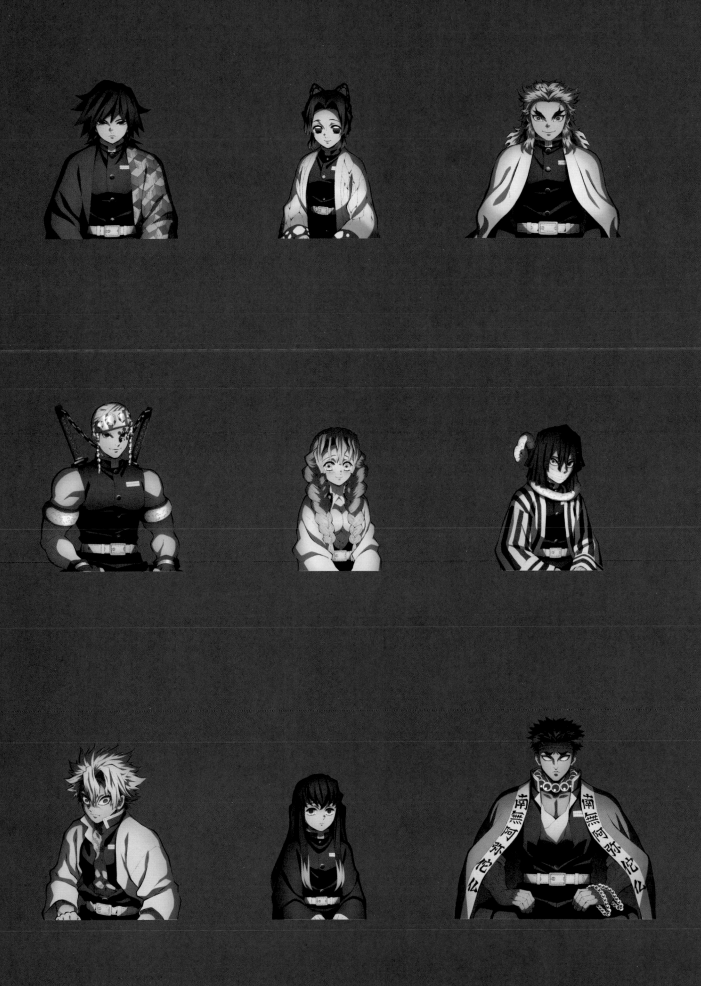

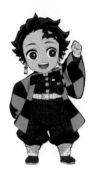 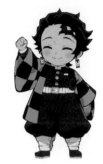 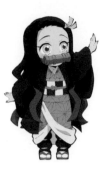

 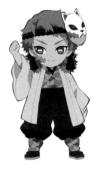

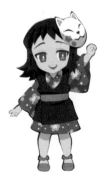

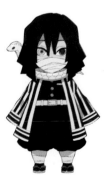

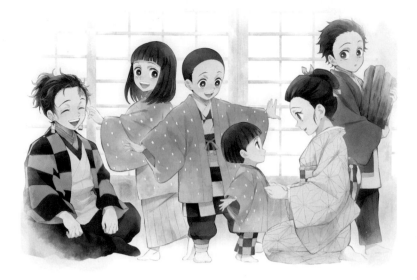

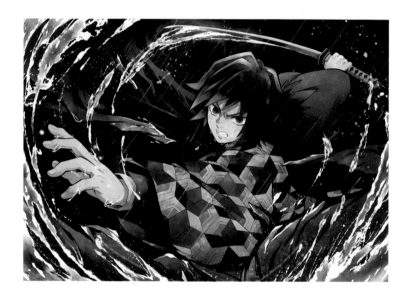

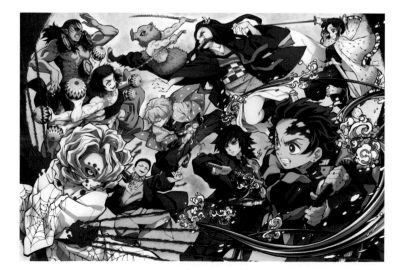

PART 7
ANIMATION PRODUCTION

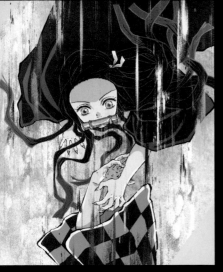

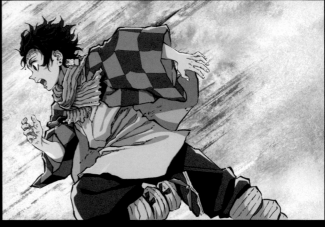

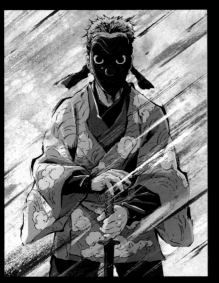

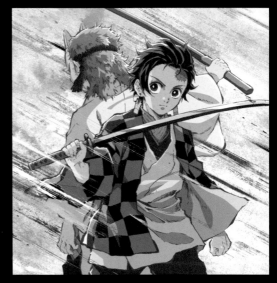

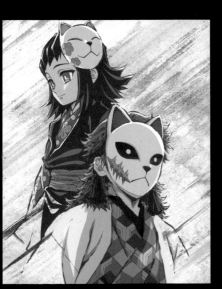

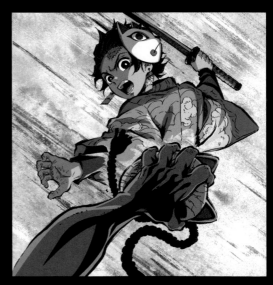

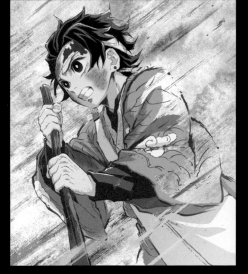

EPISODE 5 PART A

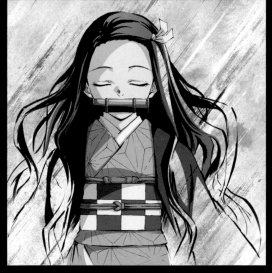

EPISODE 5 PART B

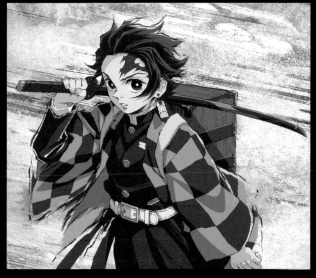

EPISODE 6 PART A

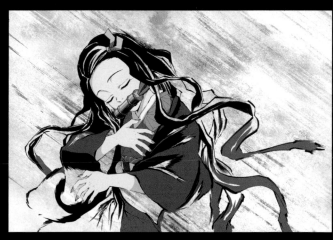

EPISODE 6 PART B

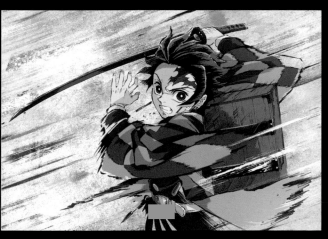

EPISODE 7 PART A

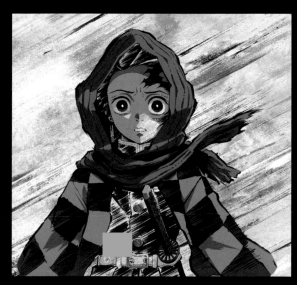

EPISODE 7 PART B

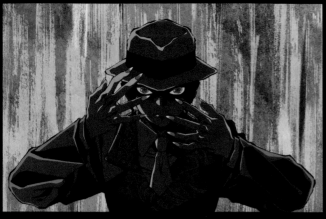

EPISODE 8 PART A

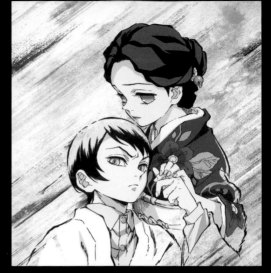

EPISODE 8 PART B

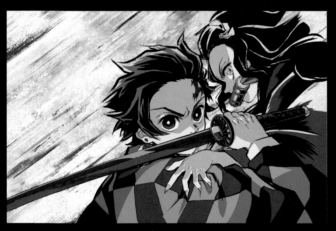

EPISODE 9 PART A

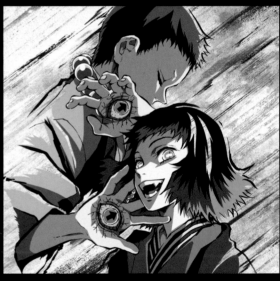

EPISODE 9 PART B

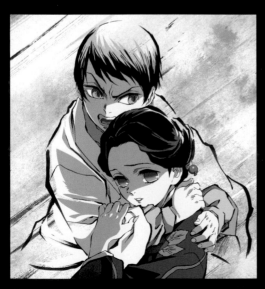

EPISODE 10 PART A

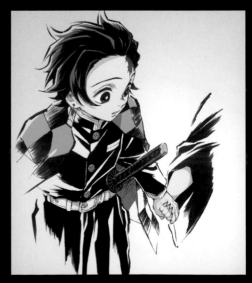

EPISODE 10 PART B

EPISODE 11　　　　　　　　PART A

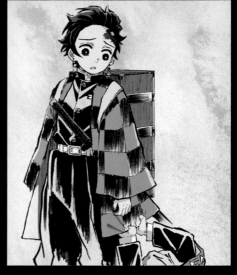

EPISODE 11　　　　　　　　PART B

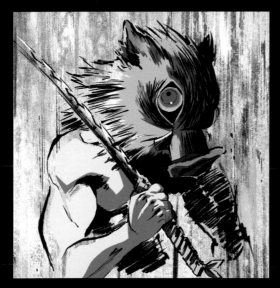

EPISODE 12　　　　　　　　PART A

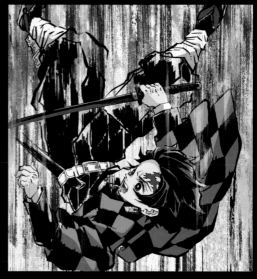

EPISODE 12　　　　　　　　PART B

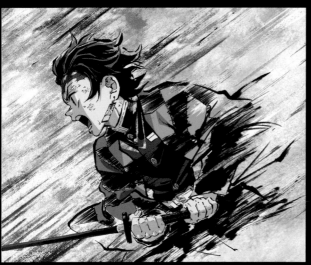

EPISODE 13　　　　　　　　PART A

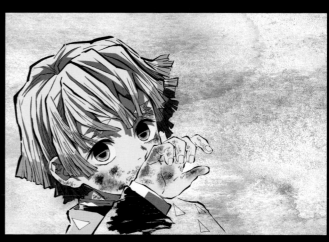

EPISODE 13　　　　　　　　PART B

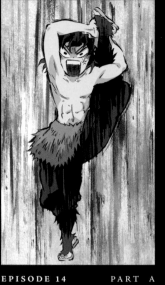

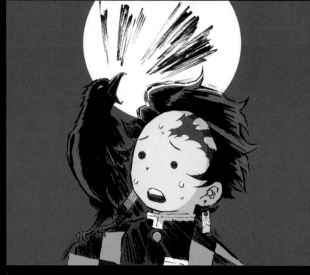

EPISODE 14 PART A EPISODE 14 PART B

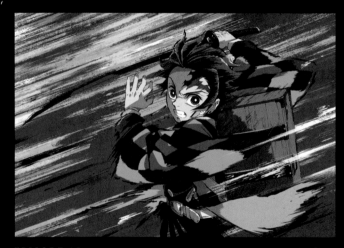

EPISODE 15 PART A

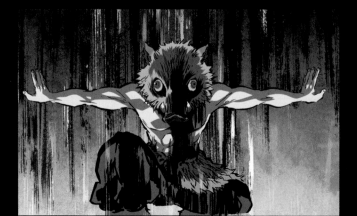

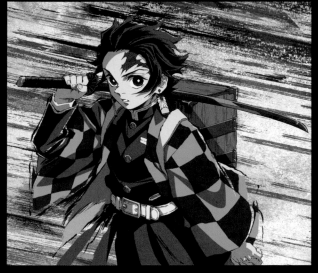

EPISODE 16 PART A

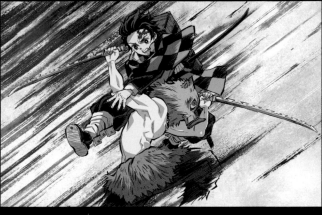

EPISODE 16 PART B

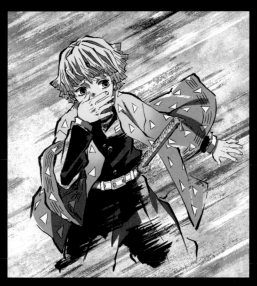

EPISODE 17 PART A

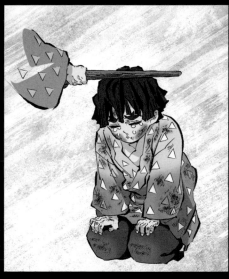

EPISODE 17 PART B

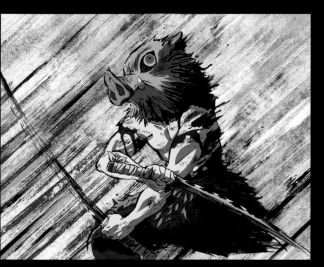

EPISODE 18 PART A

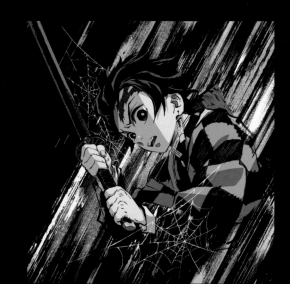

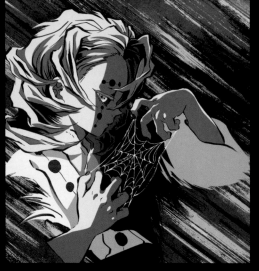

EPISODE 19 PART A

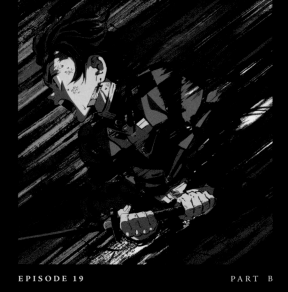

EPISODE 19 PART B

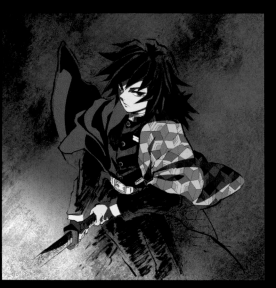

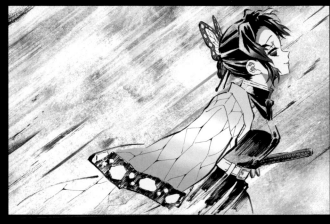

EPISODE 20 PART B

EPISODE 20 PART A

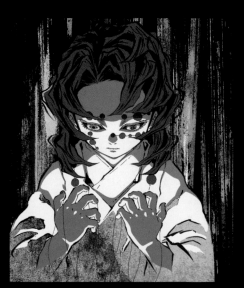

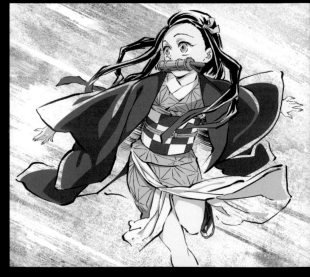

EPISODE 21 PART A

EPISODE 21 PART B

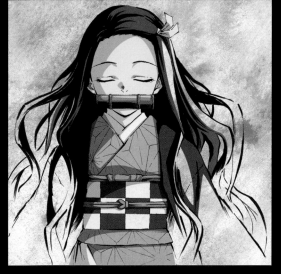

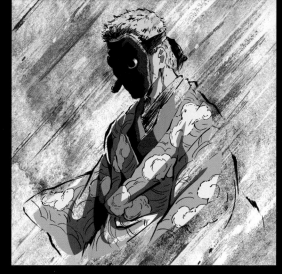

EPISODE 22 PART A EPISODE 22 PART B

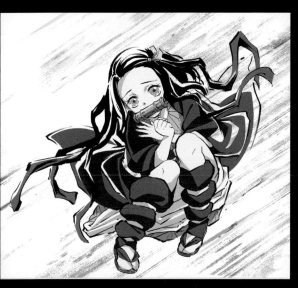

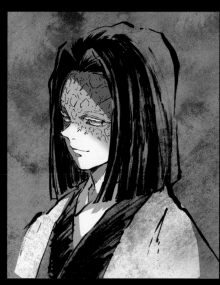

EPISODE 23 PART A EPISODE 23 PART B

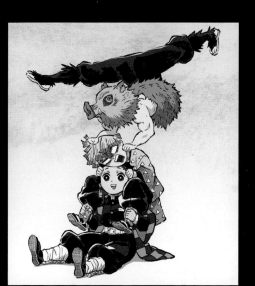

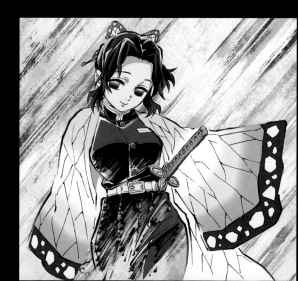

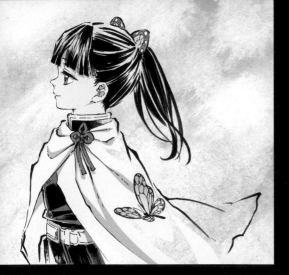

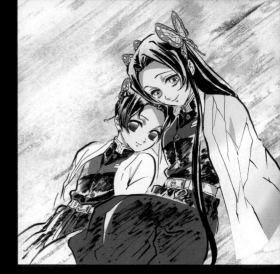

EPISODE 25 PART A EPISODE 25 PART B

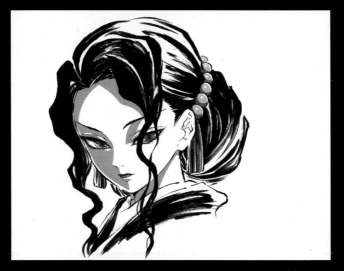

EPISODE 26 PART A

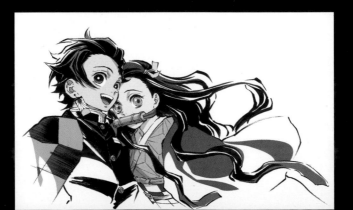

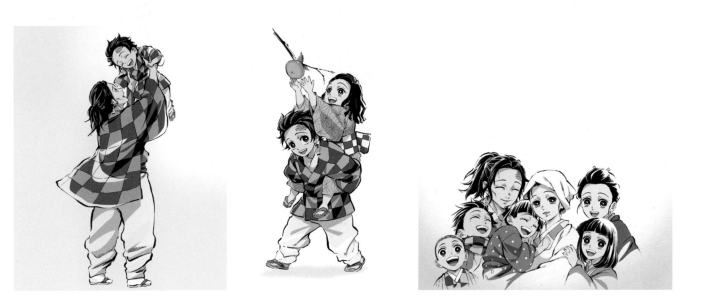

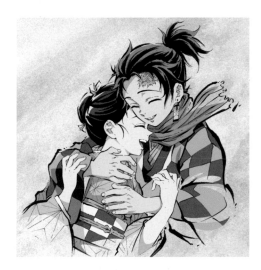

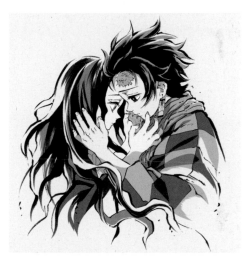

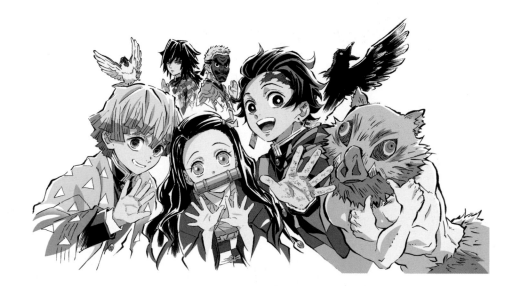

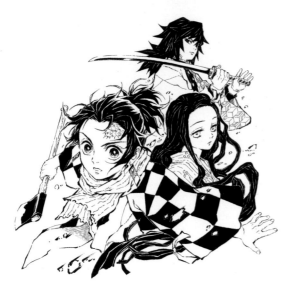

EPISODE 1

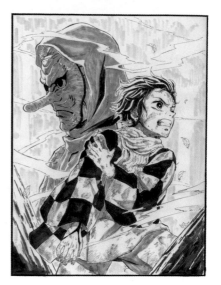

EPISODE 2

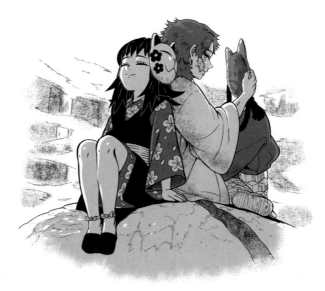

EPISODE 3

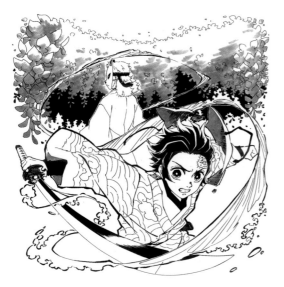

EPISODE 4

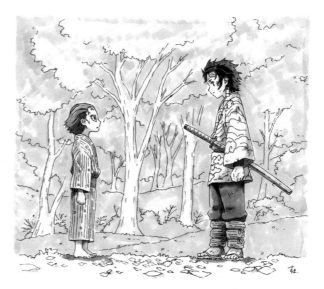

EPISODE 5

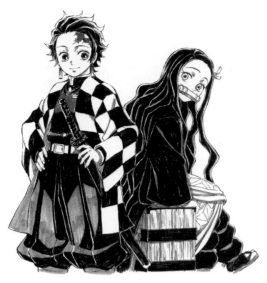

EPISODE 6

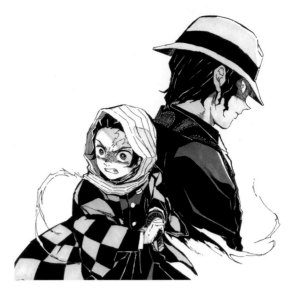

EPISODE 7

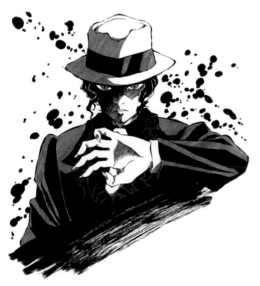

EPISODE 8

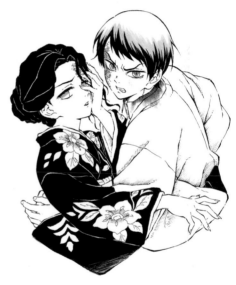

EPISODE 9

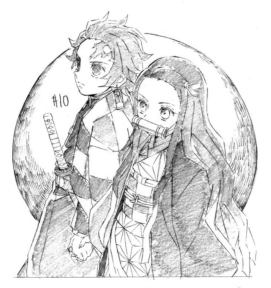

EPISODE 10

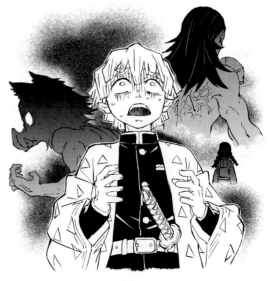

EPISODE 11

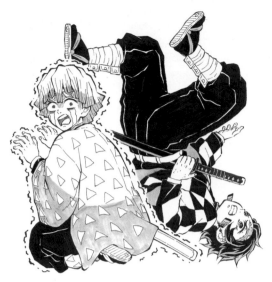

EPISODE 12

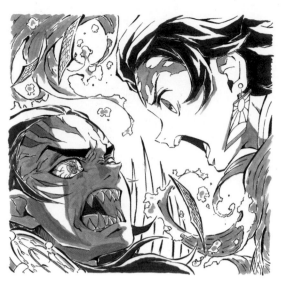

EPISODE 13

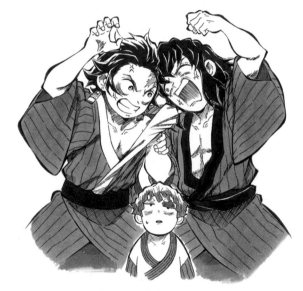

EPISODE 14

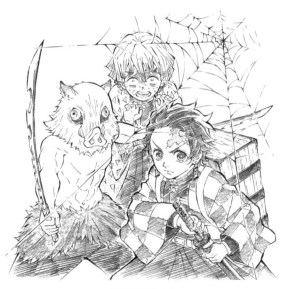

EPISODE 15

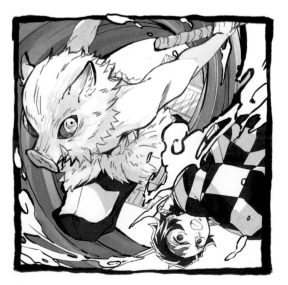

EPISODE 16

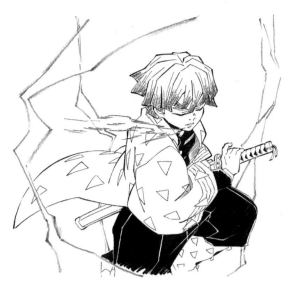

EPISODE 17

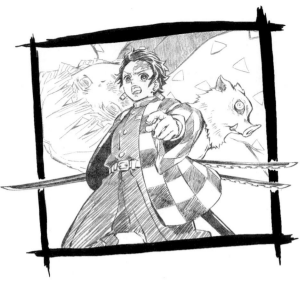

EPISODE 18

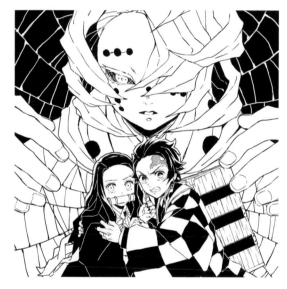

EPISODE 19

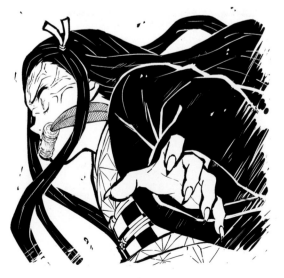

EPISODE 20

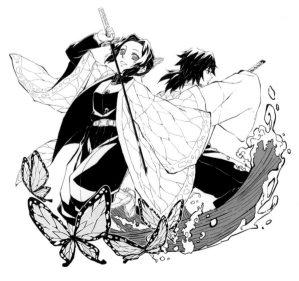

EPISODE 21

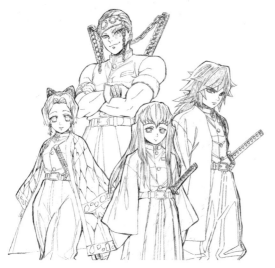

EPISODE 22

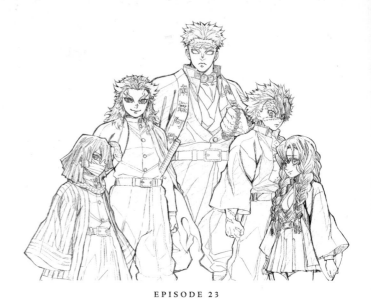

EPISODE 23

EPISODE 24

EPISODE 25

EPISODE 26

PART 8
BLU-RAY & DVD/CD

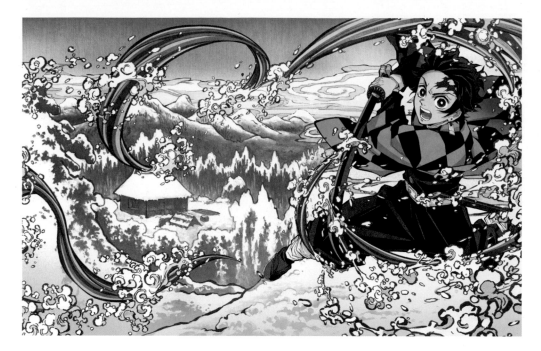

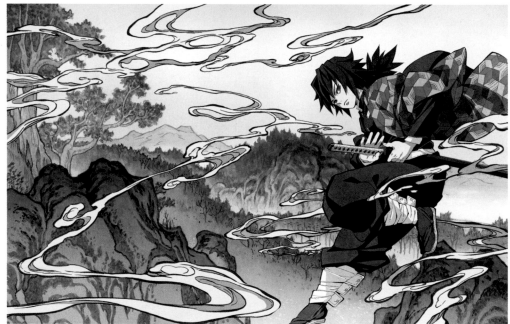

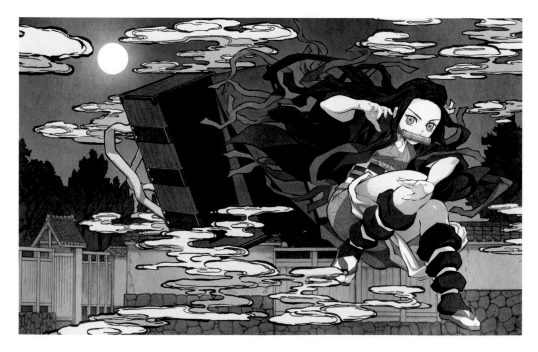

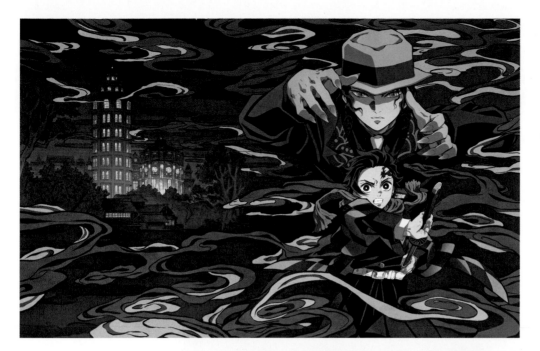

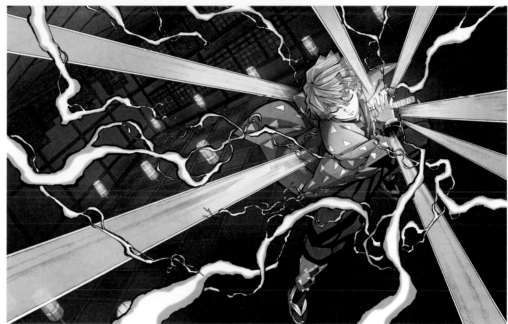

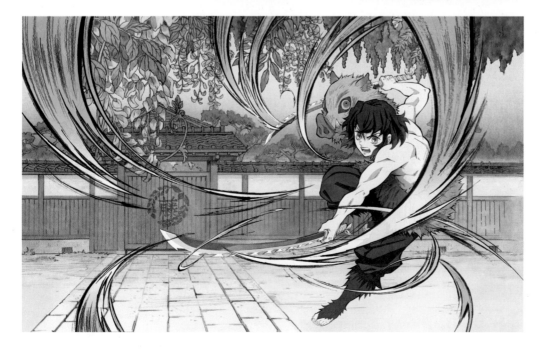

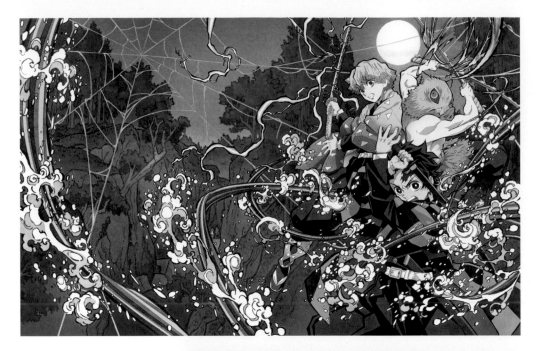

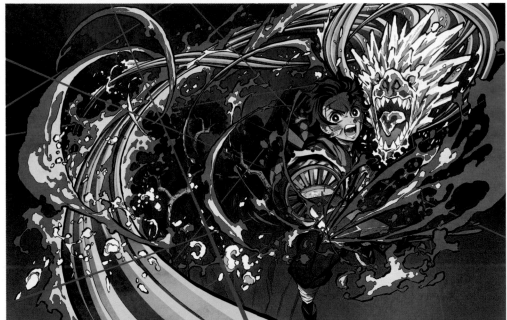

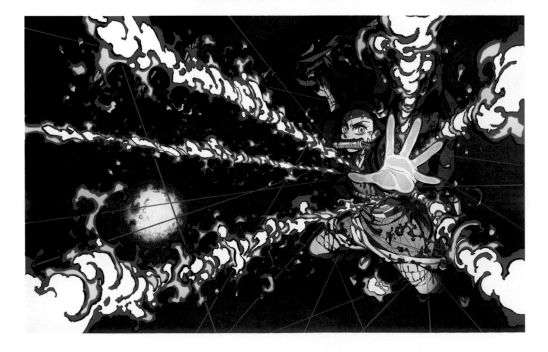

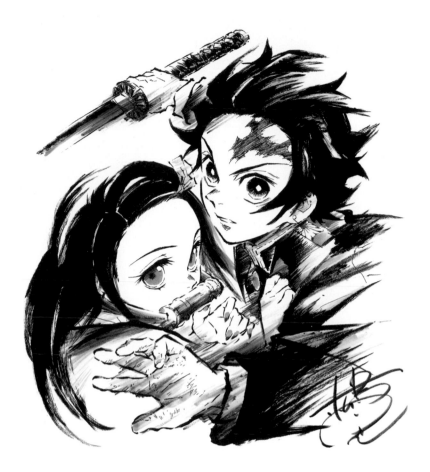

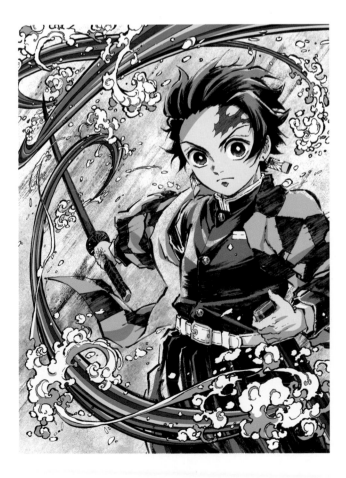

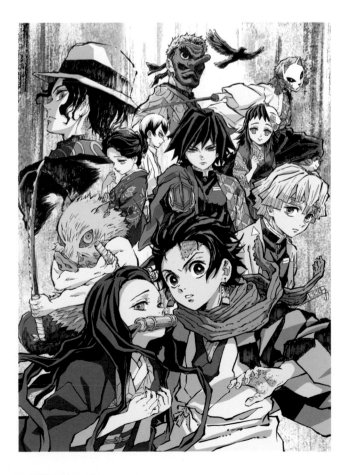

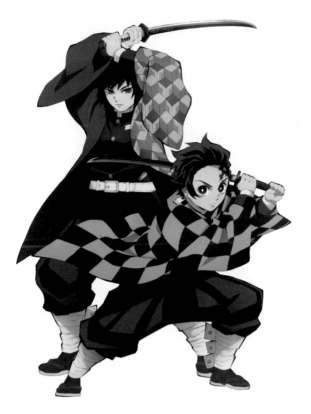

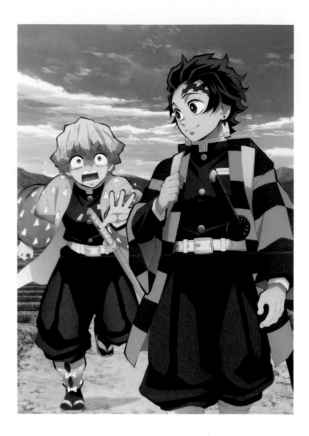

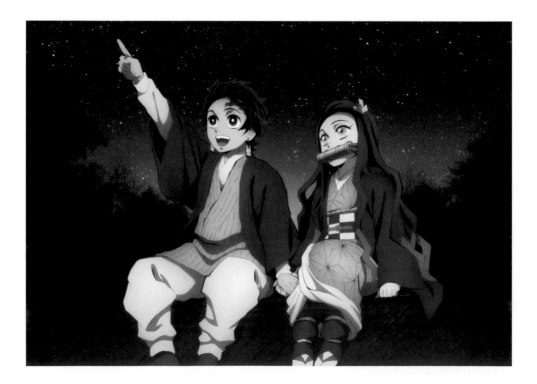

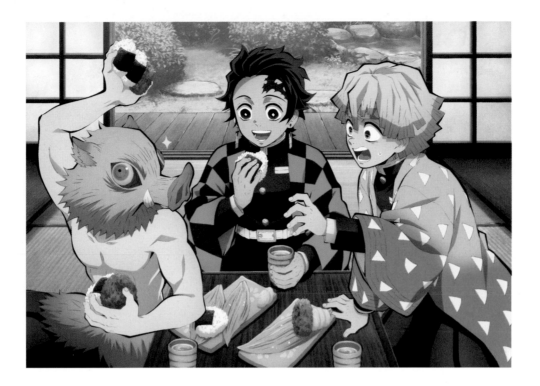

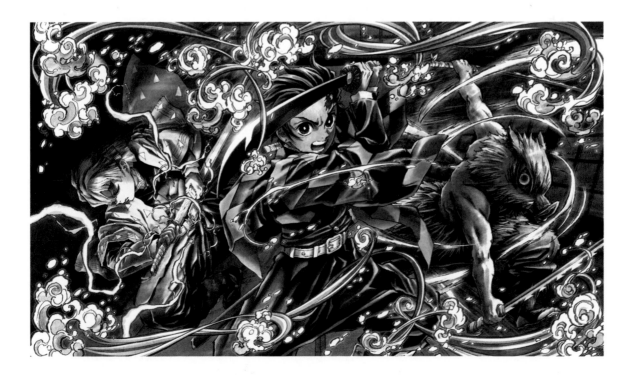

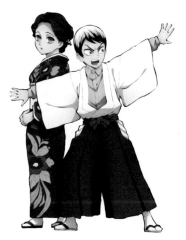

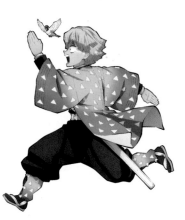

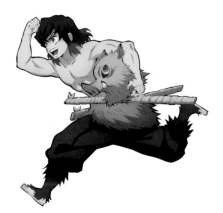

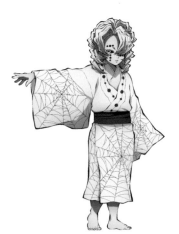

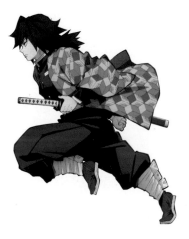

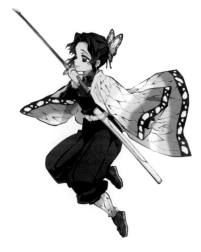

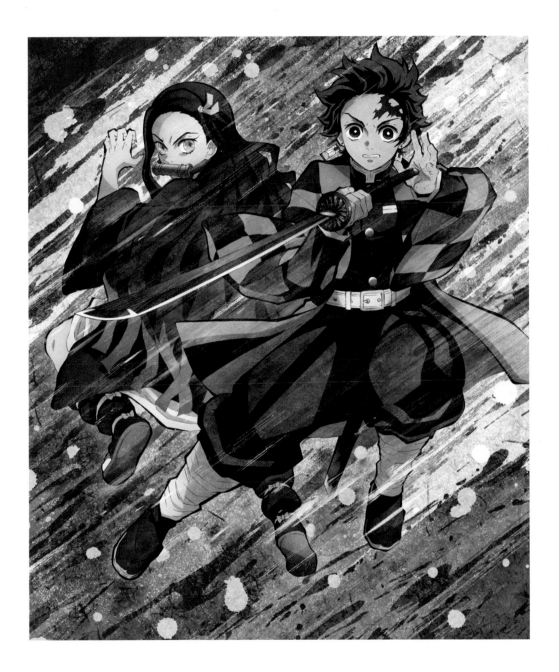

CREDITS

4 Key Visual Tanjiro Kamado Unwavering Resolve Arc Key Visual #1 Art: Akira Matsushima Paint: Hiroko Omae Background: Koji Eto Digital Work: ufotable	**8** Key Visual 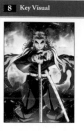 *Demon Slayer: Kimetsu no Yaiba—The Movie: Mugen Train* Teaser Visual Art: Miyuki Sato, Akira Matsushima Paint: Hiroko Omae Background: BALCOLONY. Digital Work: ufotable	**16-17** Magazine Illustration 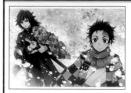 *Otomedia+*, Spring 2019 issue Art: Haruo Sotozaki (layout), Miyuki Sato (cleanup) Paint: Hiroko Omae Background: Koji Eto Digital Work: ufotable
5 Key Visual 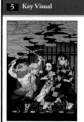 Tanjiro Kamado Unwavering Resolve Arc Key Visual #2 Art: Akira Matsushima Paint: Hiroko Omae Background: Masaru Yanaka Digital Work: ufotable	**10-11** Magazine Illustration 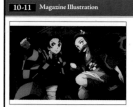 *Animage*, March 2019 issue Art: Akira Matsushima Paint: Mikako Takamine Background: Masaru Yanaka Digital Work: ufotable	**18-19** Magazine Illustration 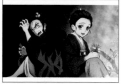 *Animage*, May 2019 issue Art: Yoko Kajiyama Paint: Hiroko Omae Background: Masaru Yanaka Digital Work: ufotable
6 Key Visual 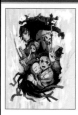 Tanjiro Kamado Unwavering Resolve Arc Brother and Sister's Bond Special Theatrical Release Visual Art: Akira Matsushima Paint: Hiroko Omae Background: Masaru Yanaka Digital Work: ufotable	**12-13** Magazine Illustration 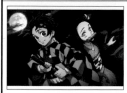 *Newtype*, March 2019 issue Art: Akira Matsushima Paint: Hiroko Omae Background: Koji Eto Digital Work: ufotable	**20-21** Magazine Illustration 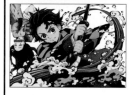 *Animedia*, May 2019 issue Art: Miyuki Sato Paint: Yurie Ushio Digital Work: ufotable
7 Key Visual 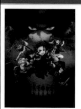 Tanjiro Kamado Unwavering Resolve Arc Key Visual #3 Art: Akira Matsushima Paint: Hiroko Omae Background: Masaru Yanaka Digital Work: ufotable	**14-15** Magazine Illustration 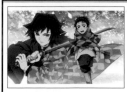 *Animage*, April 2019 issue Art: Yoko Kajiyama Paint: Ayako Higashihama Background: Koji Eto Digital Work: ufotable	**22-23** Magazine Illustration 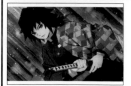 *Newtype*, May 2019 issue Art: Miyuki Sato Paint: Hiroko Omae Background: Masaru Yanaka Digital Work: ufotable

24-25 Magazine Illustration

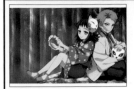

Animage, June 2019 issue
Art: Miyuki Sato
Paint: Hiroko Omae
Background: Koji Eto
Digital Work: ufotable

26-27 Magazine Illustration

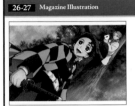

Animedia, June 2019 issue
Art: Mika Kikuchi
Paint: Hiroko Omae
Background: Masaru Yanaka
Digital Work: ufotable

28-29 Magazine Illustration

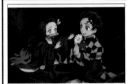

Otomedia, June 2019 issue
Art: Miyuki Sato
Paint: Hiroko Omae
Background: Masaru Yanaka
Digital Work: ufotable

30-31 Magazine Illustration

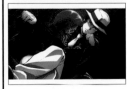

Newtype, June 2019 issue
Art: Yoko Kajiyama
Paint: Hiroko Omae
Background: Koji Eto
Digital Work: ufotable

32-33 Magazine Illustration

Animage, July 2019 issue
Art: Yoko Kajiyama
Paint: Hiroko Omae
Background: Yuko Kito
Digital Work: ufotable

34-35 Magazine Illustration

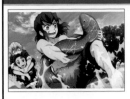

Animedia, July 2019 issue
Art: Miyuki Sato
Paint: Hiroko Omae
Background: Masaru Yanaka
Digital Work: ufotable

36-37 Magazine Illustration

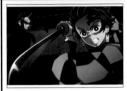

Newtype, July 2019 issue
Art: Haruo Sotozaki (layout), Mika Kikuchi (cleanup)
Paint: Hiroko Omae
Background: Kazuki Manabe
Digital Work: ufotable

38-39 Magazine Illustration

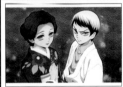

Animage, August 2019 issue
Art: Haruo Sotozaki (layout), Mika Kikuchi (cleanup)
Paint: Shizuka Matsuyama
Background: Masaru Yanaka
Digital Work: ufotable

40-41 Magazine Illustration

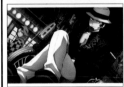

Animedia, August 2019 issue
Art: Miyuki Sato
Paint: Yurie Ushio
Background: Yuko Kito
Digital Work: ufotable

42-43 Magazine Illustration

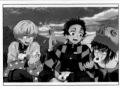

Otomedia, August 2019 issue
Art: Mika Kikuchi
Paint: Hiroko Omae
Background: Kazuki Manabe
Digital Work: ufotable

44-45 Magazine Illustration

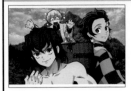

Newtype, August 2019 issue
Art: Haruo Sotozaki (layout), Yoko Kajiyama (cleanup)
Paint: Shizuka Matsuyama
Background: Masaru Yanaka
Digital Work: ufotable

46-47 Magazine Illustration

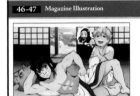

Animage, September 2019 issue
Art: Yoko Kajiyama
Paint: Hiroko Omae
Background: Sakiko Miura
Digital Work: ufotable

48-49 Magazine Illustration

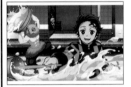

Animedia, September 2019 issue
Art: Mika Kikuchi
Paint: Mikako Takamine
Background: Yuko Kito
Digital Work: ufotable

50-51 Magazine Illustration

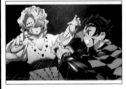

Newtype, September 2019 issue
Art: Miyuki Sato
Paint: Shizuka Matsuyama
Background: Gao Lin Li
Digital Work: ufotable

52-53 Magazine Illustration

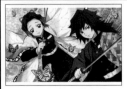

Animage, October 2019 issue
Art: Miyuki Sato
Paint: Mikako Takamine
Background: Yuko Kito
Digital Work: ufotable

54-55 Magazine Illustration

Animedia, October 2019 issue
Art: Mika Kikuchi
Paint: Sayo Okada, Mikako Takamine
Background: Koji Eto
Digital Work: ufotable

56-57 Magazine Illustration

Newtype, October 2019 issue
Art: Yoko Kajiyama
Paint: Shizuka Matsuyama
Background: Koji Eto
Digital Work: ufotable

58 Magazine Illustration

Newtype, April 2019 issue
Art: Haruo Sotozaki (layout), Yoko Kajiyama (cleanup)
Paint: Hiroko Omae
Background: Yuri Kabasawa
Digital Work: ufotable

59 Magazine Illustration

Weekly Shonen Jump Issue 18, 2019 cover
Art: Akira Matsushima
Paint: Hiroko Omae
Digital Work: ufotable

60 Magazine Illustration

Newtype, July 2019 issue cover
Art: Akira Matsushima
Paint: Hiroko Omae
Digital Work: ufotable

61 Magazine Illustration

Animedia, November 2019 issue cover
Art: Yoko Kajiyama
Paint: Hiroko Omae
Digital Work: ufotable

62 Magazine Illustration

Newtype, February 2020 issue
Art: Yoko Kajiyama
Paint: Hiroko Omae
Digital Work: ufotable

64 Character Illustrations

① ⑤ Art: Akira Matsushima / Paint: Hiroko Omae /
Digital Work: ufotable
② Art: Miyuki Sato / Paint: Hiroko Omae / Digital Work: ufotable
③ ⑥ Art: Mika Kikuchi / Paint: Hiroko Omae / Digital Work: ufotable
④ Art: Yoko Kajiyama / Paint: Hiroko Omae / Digital Work: ufotable

65 Character Illustrations

① ④ ⑥ Art: Miyuki Sato / Paint: Hiroko Omae / Digital Work: ufotable
② ⑤ Art: Yoko Kajiyama / Paint: Hiroko Omae / Digital Work: ufotable
③ ⑦ Art: Mika Kikuchi / Paint: Hiroko Omae / Digital Work: ufotable

66 Character Illustrations

Junior High and High School!! Kimetsu Academy
Art: Yui Kobayashi
Paint: Hiroko Omae
Digital Work: ufotable

68 Kimetsu no Utage

Character Illustrations
① ⑤ Art: Yoko Kajiyama /
Paint: Hiroko Omae / Digital Work: ufotable
② ③ Art: Mika Kikuchi / Paint: Hiroko Omae /
Digital Work: ufotable
④ ⑥ Art: Miyuki Sato / Paint: Hiroko Omae /
Digital Work: ufotable

Chibi Illustrations
⑦ ⑫ Art: Kumiko Nakashiki / Paint: Shizuka Matsuyama /
Digital Work: ufotable
⑧ ⑩ ⑪ Art: Kumiko Nakashiki / Paint: Yurie Ushio /
Digital Work: ufotable
⑨ Art: Kumiko Nakashiki / Paint: Mikako Takamine /
Digital Work: ufotable

69 Brother and Sister's Bond / Attendee Gift

Art: Akira Matsushima

69 AnimeJapan 2019

Commission for Aniplex Booth
Art: Mika Kikuchi
Paint: Hiroko Omae
Digital Work: ufotable

69-70 Comic Market 96

Tanjiro, Nezuko & Urokodaki Chibi Acrylic Charms
① Art: Yui Kobayashi / Paint: Mikako Takamine / Digital Work: ufotable

Ending Acrylic Stand
② Art: Miyuki Sato / Paint: Hiroko Omae / Digital Work: ufotable

Pop-Up Acrylic Mascot Set (Tanjiro & Zenitsu)
③ Art: Miyuki Sato / Paint: Shizuka Matsuyama / Digital Work: ufotable
④ Art: Mika Kikuchi / Paint: Hiroko Omae / Digital Work: ufotable

70 Comic Market 97

Pop-Up Acrylic Mascot Set (Giyu & Shinobu)
① Art: Mika Kikuchi (layout), Shuma Hoshino (cleanup) /
Paint: Hiroko Omae / Digital Work: ufotable
② Art: Miyuki Sato (layout), Junka Sakagami (cleanup) /
Paint: Hiroko Omae / Digital Work: ufotable

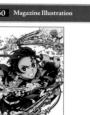

Staff Commemorative Book
① Art: Haruo Sotozaki (layout), Yuka Kawashima, Junka Sakagami, Yosuke Takeda (cleanup) / Paint: Shizuka Matsuyama / Background: Masaru Yanaka / Digital Work: ufotable

Intermission Art Book
~Tanjiro Kamado Unwavering Resolve Arc~
② Art: Akira Matsushima / Paint: Hiroko Omae / Digital Work: ufotable

| 70 | Jump Festa 2020 |

Commission for Aniplex & Sony Music Entertainment Booth
Art: Miyuki Sato, Mika Kikuchi, Yoko Kajiyama
Paint: Hiroko Omae
Background: Yuko Kito
Digital Work: ufotable

| 71 | Machi ★ Asobi vol.22 |

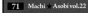
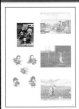

Chibi Commissions
Art: Aya Tanaka
Paint: Sayo Okada
Background: Masaru Yanaka
Digital Work: ufotable

| 71 | Machi ★ Asobi vol.23 |

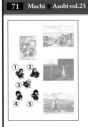

Chibi Commissions
①②⑤ Art: Aya Tanaka / Paint: Shizuka Matsuyama / Digital Work: ufotable
③④ Art: Aya Tanaka / Paint: Sayo Okada / Digital Work: ufotable

| 71-72 | Machi ★ Asobi vol.23 |

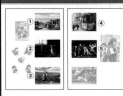

Bizan Commissions
① Art: Sonoko Shirai / Paint: Hiroko Omae / Background: Mai Ito / Digital Work: ufotable
② Art: Sonoko Shirai / Paint: Hiroko Omae / Background: Chen Kun, Haruna Sato / Digital Work: ufotable

③ & ⑤ Art: Sonoko Shirai / Paint: Hiroko Omae / Background: Yuko Kito / Digital Work: ufotable
④ Art: Sonoko Shirai / Paint: Hiroko Omae / Background: Yumie Kato, Chen Kun, Sakiko Miura, Mio Miyamoto / Digital Work: ufotable

| 72 | Machi ★ Asobi vol.23 |

Sweets Collaboration: Assorted Set
① Art: Sonoko Shirai / Paint: Shizuka Matsuyama / Background: Yuko Kito / Digital Work: ufotable

Sweets Collaboration: Mamma Rosa
② Art: Sonoko Shirai / Paint: Mikako Takamine / Background: Mai Ito, Satomi Gunji, Chen Kun, Mio Miyamoto / Digital Work: ufotable
[sign text: Machi ★Asobi]

| 74 | Character Birthday Illustrations |

Tanjiro Kamado, 2019
① Art: Kumiko Nakashiki / Paint: Hiroko Omae / Digital Work: ufotable [red text: Celebration]

Zenitsu Agatsuma, 2019
② Art: Aya Tanaka / Paint: Shizuka Matsuyama / Digital Work: ufotable
[red text: Celebration; vertical banner: Today's Star, 9/3]

Nezuko Kamado, 2019
③ Art: Aya Tanaka / Paint: Hiroko Omae / Digital Work: ufotable
[banner left: Happy Birthday; banner right: Nezuko; red text: Celebration]

| 74 | Seasonal Illustrations |

New Year's card, 2019
① Art: Akira Matsushima / Paint: Hiroko Omae / Digital Work: ufotable

Chibis for Setsubun, 2019
② Art: Aya Tanaka / Paint: Hiroko Omae / Background: Masaru Yanaka / Digital Work: ufotable

| 74 | Seasonal Illustrations |

Chibis for Tanabata, 2019
① Art: Aya Tanaka / Paint: Shizuka Matsuyama, Hiroko Omae / Background: Yuko Kito / Digital Work: ufotable

Chibis for Christmas, 2019
② Art: Kumiko Nakashiki / Paint: Hiroko Omae / Digital Work: ufotable

| 75 | Seasonal Illustrations |

Chibis for New Year's, 2020
① Art: Aya Tanaka / Paint: Shizuka Matsuyama / Background: Masaru Yanaka / Digital Work: ufotable [black text: Happy New Year]

Chibis for 1 Million Followers, 2020
② Art: Aya Tanaka / Paint: Hiroko Omae / Digital Work: ufotable
[pink and white text: Thank you for 1 million followers!]

Chibis for Setsubun, 2020
③ Art: Yui Kobayashi / Paint: Yurie Ushio / Digital Work: ufotable

| 75 | Seasonal Illustrations |

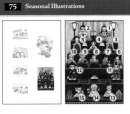

Chibis for Valentine's Day, 2020
① Art: Kumiko Nakashiki / Paint: Hiroko Omae / Digital Work: ufotable
Chibis for White Day, 2020
② Art: Kumiko Nakashiki / Paint: Hiroko Omae / Digital Work: ufotable

| 75 | Seasonal Illustrations |

Chibis for Hinamatsuri, 2020
①–⑤ Art: Aya Tanaka / Paint, Digital Work: ufotable
⑤–⑩ Art: Mika Bando / Paint, Digital Work: ufotable
⑪–⑮ Art: Yui Kobayashi / Paint, Digital Work: ufotable

| 76 | Seasonal Illustrations |

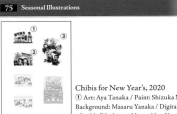

Chibis for Summer Festival, 2019
①–⑤ Art: Kumiko Nakashiki / Paint, Digital Work: ufotable

Chibis for Tsukimi, 2019
⑥–⑪ Art: Aya Tanaka / Paint: Yurie Ushio, Sayo Okada, Mikako Takamine / Digital Work: ufotable

| 77 | Seasonal Illustrations |

Chibis for Halloween, 2019
①③ Art: Kumiko Nakashiki / Paint: Mikako Takamine / Digital Work: ufotable
②④ Art: Kumiko Nakashiki / Paint: Shizuka Matsuyama / Digital Work: ufotable
⑤⑨ Art: Aya Tanaka / Paint: Shizuka Matsuyama / Digital Work: ufotable

⑥ Art: Yui Kobayashi / Paint: Sayo Okada / Digital Work: ufotable
⑦ Art: Yui Kobayashi / Paint: Mikako Takamine / Digital Work: ufotable
⑧ Art: Aya Tanaka / Paint: Mikako Takamine / Digital Work: ufotable

| 78 | Seasonal Illustrations |

Chibis for Halloween, 2019
① Art: Yui Kobayashi / Paint: Sayo Okada / Digital Work: ufotable
② Art: Aya Tanaka / Paint: Shizuka Matsuyama / Digital Work: ufotable
③ Art: Mika Bando / Paint: Yurie Ushio / Digital Work: ufotable
④ Art: Mika Bando / Paint: Sayo Okada / Digital Work: ufotable

⑤ Art: Yui Kobayashi / Paint: Mikako Takamine / Digital Work: ufotable
⑥ Art: Kumiko Nakashiki / Paint: Shizuka Matsuyama / Digital Work: ufotable
⑦ Art: Yui Kobayashi / Paint: Yurie Ushio / Digital Work: ufotable
⑧ Art: Aya Tanaka / Paint: Mikako Takamine / Digital Work: ufotable
⑨ Art: Yui Kobayashi / Paint: Shizuka Matsuyama / Digital Work: ufotable

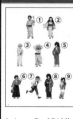

Lawson *Demon Slayer: Kimetsu no Yaiba* Campaign, July 2019
① Art: Haruo Sotozaki (layout), Miyuki Sato (cleanup) / Paint: Hiroko Omae / Digital Work: ufotable
②⑤ Art: Yoko Kajiyama / Paint: Hiroko Omae / Digital Work: ufotable
③ Art: Mika Kikuchi / Paint: Hiroko Omae / Digital Work: ufotable
④ Art: Miyuki Sato / Paint: Hiroko Omae / Digital Work: ufotable

Animate Real Riddle Game "Defeat the Demon Hiding in the Toy Store!", January 2020
⑥–⑨ Art: Kaori Endo / Paint: Hiroko Omae / Digital Work: ufotable

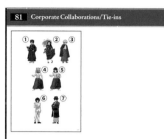

Toei Kyoto Studio Park: Kyo-no-Oshigoto, August 2019
①② Art: Miyuki Sato / Paint: Hiroko Omae / Digital Work: ufotable
③⑥ Art: Mika Kikuchi / Paint: Hiroko Omae / Digital Work: ufotable
④⑤⑦ Art: Yoko Kajiyama / Paint: Hiroko Omae / Digital Work: ufotable

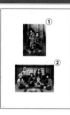

Movic, September 2019
① Art: Yoko Kajiyama, Miyuki Sato / Paint: Hiroko Omae / Background: Masaru Yanaka / Digital Work: ufotable

Pop-Up Store in Loft ~Danran~, October 2019
② Art: Yukari Takeuchi / Paint: Hiroko Omae / Background: Masaru Yanaka / Digital Work: ufotable

Kimetsu Café in Sweets Paradise, January 2020
①③ Art: Miyuki Sato / Paint: Yurie Ushio / Digital Work: ufotable
② Art: Mika Kikuchi (layout), Misaki Nakamura (cleanup) / Paint: Yurie Ushio / Digital Work: ufotable
④⑥ Art: Yoko Kajiyama / Paint: Yurie Ushio / Digital Work: ufotable
⑤ Art: Mika Kikuchi (layout), Madoka Kumagai (cleanup) / Paint: Yurie Ushio / Digital Work: ufotable

Craftholic Collaboration #1, March 2020
⑦⑨ Art: Mika Kikuchi / Paint: Shizuka Matsuyama / Digital Work: ufotable
⑧ Art: Miyuki Sato / Paint: Shizuka Matsuyama / Digital Work: ufotable
⑩ Art: Yoko Kajiyama / Paint: Shizuka Matsuyama / Digital Work: ufotable

Ensky (*Jump Festa 2020*), December 2019
① Art: Mika Kikuchi / Paint: Shizuka Matsuyama / Digital Work: ufotable
② Art: Yoko Kajiyama / Paint: Yurie Ushio / Digital Work: ufotable
③ Art: Miyuki Sato / Paint: Shizuka Matsuyama / Digital Work: ufotable
④ Art: Mika Kikuchi / Paint: Mikako Takamine / Digital Work: ufotable
⑤ Art: Yoko Kajiyama / Paint: Shizuka Matsuyama / Digital Work: ufotable

Morinaga & Company Campaign, February 2020
⑥⑦ Art: Yoko Kajiyama / Paint: Hiroko Omae / Digital Work: ufotable
⑧–⑩ Art: Miyuki Sato / Paint: Hiroko Omae / Digital Work: ufotable
⑨ Art: Mika Kikuchi / Paint: Hiroko Omae / Digital Work: ufotable

Hashira Meeting Illustrations
① Art: Mika Kikuchi (layout), Sonoko Shirai (cleanup) / Paint: Hiroko Omae / Digital Work: ufotable
② Art: Yoko Kajiyama (layout), Sonoko Shirai (cleanup) / Paint: Hiroko Omae / Digital Work: ufotable
③ Art: Yoko Kajiyama (layout), Natsuki Soga (cleanup) / Paint: Hiroko Omae / Digital Work: ufotable
④ Art: Miyuki Sato (layout), Misaki Nakamura (cleanup) / Paint: Hiroko Omae / Digital Work: ufotable
⑤ Art: Miyuki Sato (layout), Shuma Hoshino (cleanup) / Paint: Hiroko Omae / Digital Work: ufotable
⑥ Art: Mika Kikuchi (layout), Junka Sakagami (cleanup) / Paint: Hiroko Omae / Digital Work: ufotable
⑦ Art: Yoko Kajiyama (layout), Yuka Kawashima (cleanup) / Paint: Hiroko Omae / Digital Work: ufotable
⑧ Art: Mika Kikuchi (layout), Madoka Kumagai (cleanup) / Paint: Hiroko Omae / Digital Work: ufotable
⑨ Art: Miyuki Sato (layout), Hirotaka Kamato (cleanup) / Paint: Hiroko Omae / Digital Work: ufotable

Connected Chibis (Season 1)
①②④ Art: Mika Bando / Paint: Mikako Takamine / Digital Work: ufotable
③ Art: Aya Tanaka / Paint: Mikako Takamine / Digital Work: ufotable

Connected Chibis (Season 2)
⑤ Art: Mika Bando / Paint: Shizuka Matsuyama / Digital Work: ufotable
⑥–⑧ Art: Aya Tanaka / Paint: Shizuka Matsuyama / Digital Work: ufotable

Connected Chibis (Season 3)
①–④ Art: Kumiko Nakashiki / Paint: Yurie Ushio / Digital Work: ufotable

Connected Chibis (Season 4)
⑤⑥ Art: Mika Bando / Paint: Hiroko Omae / Digital Work: ufotable
⑦⑧ Art: Aya Tanaka / Paint: Hiroko Omae / Digital Work: ufotable

Drama CD Illustration: "Bygone Days of Brother and Sister"
① Art, Paint, Background, Digital Work: Kaori Endo

Drama CD Illustration: "Blade Unforgotten"
② Art, Paint, Background, Digital Work: Kaori Endo

Mobile Game *Keppu Kengeki Royale* Key Visual
Art: Akira Matsushima
Paint: Hiroko Omae
Digital Work: ufotable

Episode 2–Episode 10 A/B Parts
Art: Akira Matsushima
Paint: Hiroko Omae

Episode 11–Episode 18 A/B Parts
Art: Akira Matsushima
Paint: Hiroko Omae

Episode 19–Episode 26 A/B Parts
Art: Akira Matsushima
Paint: Hiroko Omae

Art: Akira Matsushima
Paint: Hiroko Omae

99 Tanjiro Kamado Unwavering Resolve Arc
Episode 26 Promotional Illustration

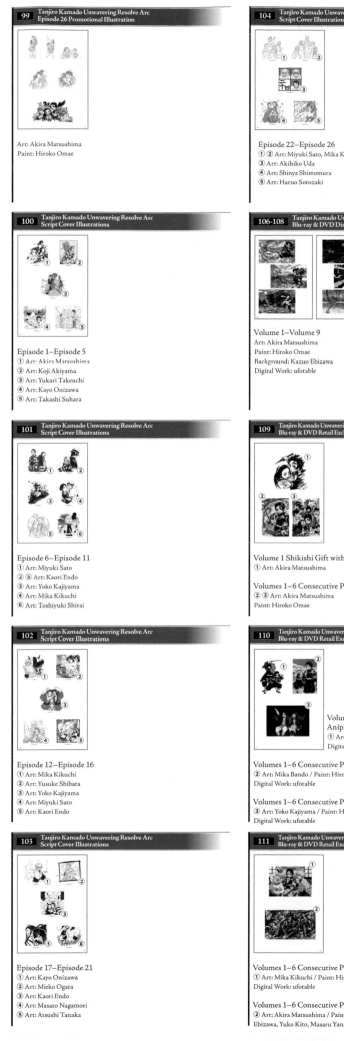

Art: Akira Matsushima
Paint: Hiroko Omae

100 Tanjiro Kamado Unwavering Resolve Arc
Script Cover Illustrations

Episode 1–Episode 5
① Art: Akira Matsushima
② Art: Koji Akiyama
③ Art: Yukari Takeuchi
④ Art: Kayo Onizawa
⑤ Art: Takashi Suhara

101 Tanjiro Kamado Unwavering Resolve Arc
Script Cover Illustrations

Episode 6–Episode 11
① Art: Miyuki Sato
②⑤ Art: Kaori Endo
③ Art: Yoko Kajiyama
④ Art: Mika Kikuchi
⑥ Art: Toshiyuki Shirai

102 Tanjiro Kamado Unwavering Resolve Arc
Script Cover Illustrations

Episode 12–Episode 16
① Art: Mika Kikuchi
② Art: Yusuke Shibata
③ Art: Yoko Kajiyama
④ Art: Miyuki Sato
⑤ Art: Kaori Endo

103 Tanjiro Kamado Unwavering Resolve Arc
Script Cover Illustrations

Episode 17–Episode 21
① Art: Kayo Onizawa
② Art: Mieko Ogata
③ Art: Kaori Endo
④ Art: Masato Nagamori
⑤ Art: Atsushi Tanaka

104 Tanjiro Kamado Unwavering Resolve Arc
Script Cover Illustrations

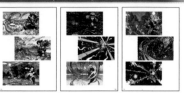
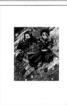

Episode 22–Episode 26
①② Art: Miyuki Sato, Mika Kikuchi, Yoko Kajiyama
③ Art: Akihiko Uda
④ Art: Shinya Shimomura
⑤ Art: Haruo Sotozaki

106-108 Tanjiro Kamado Unwavering Resolve Arc
Blu-ray & DVD Disc Jacket

Volume 1–Volume 9
Art: Akira Matsushima
Paint: Hiroko Omae
Background: Kazuo Ebizawa
Digital Work: ufotable

109 Tanjiro Kamado Unwavering Resolve Arc
Blu-ray & DVD Retail Exclusives

Volume 1 Shikishi Gift with Purchase
① Art: Akira Matsushima

Volumes 1–6 Consecutive Purchase Gift Slipcase Box
②③ Art: Akira Matsushima
Paint: Hiroko Omae

110 Tanjiro Kamado Unwavering Resolve Art
Blu-ray & DVD Retail Exclusives

Volumes 1–6 Consecutive Purchase Gift:
Aniplex+
① Art: Miyuki Sato / Paint: Hiroko Omae /
Digital Work: ufotable

Volumes 1–6 Consecutive Purchase Gift: Tsutaya
② Art: Mika Bando / Paint: Hiroko Omae / Background: Yuko Kito /
Digital Work: ufotable

Volumes 1–6 Consecutive Purchase Gift: Amazon
③ Art: Yoko Kajiyama / Paint: Hiroko Omae / Background: Chen Kun /
Digital Work: ufotable

111 Tanjiro Kamado Unwavering Resolve Arc
Blu-ray & DVD Retail Exclusives

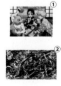

Volumes 1–6 Consecutive Purchase Gift: Animate
① Art: Mika Kikuchi / Paint: Hiroko Omae / Background: Yuko Kito /
Digital Work: ufotable

Volumes 1–6 Consecutive Purchase Gift: ufotable
② Art: Akira Matsushima / Paint: Hiroko Omae / Background: Kazuo
Ebizawa, Yuko Kito, Masaru Yanaka

112 Tanjiro Kamado Unwavering Resolve Arc
Blu-ray & DVD Retail Exclusives

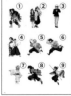

Per Volume Gifts w/ Purchase: ufotable
①⑤ Art: Mika Kikuchi / Paint: Hiroko Omae /
Digital Work: ufotable
② Art: Miyuki Sato / Paint: Sayo Okada / Digital
Work: ufotable
③ Art: Miyuki Sato / Paint: Yurie Ushio /
Digital Work: ufotable

④⑥ Art: Yoko Kajiyama / Paint: Mikako Takamine / Digital Work:
ufotable
⑦ Art: Miyuki Sato / Paint: Mikako Takamine / Digital Work: ufotable
⑧ Art: Mika Kikuchi / Paint: Shizuka Matsuyama / Digital Work: ufotable
⑨ Art: Mika Kikuchi / Paint: Mikako Takamine / Digital Work: ufotable

113 Theme Song CD

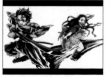

LiSA / "Gurenge"
Art: Haruo Sotozaki (layout), Yoko Kajiyama (cleanup)
Paint: Hiroko Omae
Background: Masaru Yanaka
Digital Work: ufotable

Poster *The Art of Demon Slayer: Kimetsu no Yaiba
the Anime*, Volume 1 Poster Illustration

Art: Akira Matsushima
Paint: Hiroko Omae

**THE ART OF
DEMON SLAYER:
KIMETSU NO YAIBA
THE ANIME: VOLUME 1**
Shonen Jump Edition

Illustrations By
UFOTABLE

Original Work by
KOYOHARU GOTOUGE

ANIMATION "KIMETSU NO YAIBA"
ILLUSTRATION KIROKUSHU ICHI
© 2022 by Koyoharu Gotouge, ufotable
All rights reserved. First published in Japan in 2022
by SHUEISHA Inc., Tokyo.
English translation rights arranged by SHUEISHA Inc.

© Koyoharu Gotoge / SHUEISHA, Aniplex, ufotable

TRANSLATION Evan Galloway
DESIGN Jimmy Presler & Paul Padurariu
EDITOR David Brothers

Japanese Edition Credits
EDITORIAL/PLANNING Chie Nagano, Miki Onizawa, Aki Mugishima,
Kota Niisato (Wedge Holdings Co., Ltd.)
DESIGN Yuri Sugawara, Yoko Nose, Natsumi Matsuba,
BGS Production Dept.: Yuki Otani (Banana Grove Studio Co., Ltd.)
PRINTING DIRECTOR Shizu Tominaga (Toppan Printing Co., Ltd.)
EDITORIAL SUPPORT ufotable, Inc.
Aniplex Inc.
Weekly Shonen Jump Editorial Department

Printed in China

Published by VIZ Media, LLC
P.O. Box 77010
San Francisco, CA 94107

Library of Congress Control Number: 2022949731

10 9 8 7 6 5 4 3 2 1
First printing, August 2023

viz.com